Wild ORIGAMI

Amazing Animals You Can Make

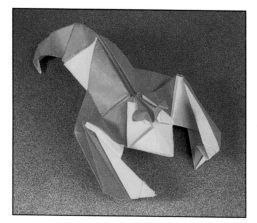

P. D. Tuyen

Sterling Publishing Co., Inc. New York

Contents

Illustrations by Pham Dinh Tuyen, Hanoi
Photos by art TECH Studios, GmbH, Idstein
Translated by Annette Englander

Library of Congress Cataloging-in-Publication Data

Tuyen, P. D. (Pham Dinh)
 [Ideen über Ideen. English]
 Wild origami : amazing animals you can make / by P.D. Tuyen.
 p. cm.
 Includes index.
 ISBN 0-8069-1380-0
 1. Origami. 2. Animals in art. I. Title.
TT870.T889713 1996
736'.982—dc20 96-28264
 CIP

1 3 5 7 9 10 8 6 4 2

Published 1996 by Sterling Publishing Company, Inc.
387 Park Avenue South, New York, N.Y. 10016
Originally published in Germany by Falken-Verlag GmbH Niedernhausen/Ts.
under the title *Ideen über Ideen Origami: Neue Figuren für Fortgeschrittene*
© 1996 by Falken-Verlag GmbH Niedernhausen/Ts.
English translation © 1996 by Sterling Publishing Co., Inc.
Distributed in Canada by Sterling Publishing
% Canadian Manda Group, One Atlantic Avenue, Suite 105
Toronto, Ontario, Canada M6K 3E7
Distributed in Great Britain and Europe by Cassell PLC
Wellington House, 125 Strand, London WC2R 0BB, England
Distributed in Australia by Capricorn Link (Australia) Pty Ltd.
P.O. Box 6651, Baulkham Hills, Business Centre, NSW 2153, Australia
Manufactured in the United States of America
All rights reserved

Sterling ISBN 0-8069-1380-0

Preface

The world of Origami is based on three elementary steps: the paper square, the basic form and the different folding-figures. Each of the manifold and intricate motifs stems from the simple square piece of paper. In East Asia, the circle and square are considered perfect origin-sources—the heavens are round and the earth is square. Out of these forms is developed, similar to the natural world, first, the simple basic forms and then the different folding-figures. Based on this philosophical belief, using scissors to cut or glue to join paper is unthinkable. The pure paper-form stands by itself. The charm and diversity of the art of Origami is due not only to the enchanting effect of the individual folding-models but also to the possibilities in which each basic form, in as few as six to ten steps, can open up into an almost unlimited world.

The interest in Origami generated from my first book, *Classic Origami,* has encouraged me to write this second book. In it, I have included eight basic forms and nineteen folding models. Some of the basic forms are published for the first time in this book and, based on them, make numerous new and interesting animal figures. These forms and folding models are presented step-by-step in picture and words.

I hope this book wins many new friends into the art of Origami.

Pham Dinh Tuyen

Important Tips Up Front

The Origami Paper

Paper is the only material one needs for Origami. In order to create really beautiful and lasting Origami models, the paper must be sturdy enough to fold and stand the figure. Paper stores sell Origami paper that has different-colored sides, one side usually white. The choice of the color and quality of the paper can contribute to the result and beauty of the figures. Typewriter and gift-wrapping paper are good to work with, but they have to be made into a square first.

Basic Rules

- It is important to work carefully and to make sure that edges and corners are folded evenly. The smallest inaccuracy in a fold will inevitably lead to difficulties later on. The sharpness of the folds has a direct influence on the beauty of the figures.
- The drawings should be studied carefully before you begin. Each drawing shows you how your figure should look at each stage and gives you instructions for the next step. To make it clearer, the drawings are designed in two colors so that you should pay attention to the change of the color sides after each drawing.

- Bring your figure after each folding step exactly into the illustrated position and only take the next step when you are sure about its accuracy. Prefolding the dotted lines shown in the drawing will help guide you through the step.
- Anyone who has little experience with Origami should first try the simpler figures. Success with those is the basis for the next steps.
- If, at some point, making a certain figure is a little difficult for you, skip that one for the time being. When you advance further in the book and improve your folding technique, try it again. You will realize that the difficulties solve themselves.

Symbols

Individual folding-steps is described with symbols as well as in the text. Although a binding symbol-system does not exist in Origami yet, I have used symbols that are used widespread and, I believe, will assert themselves to become standards.

It is best to memorize the symbols right from the beginning, starting with the most important symbols for mountain and valley folds.

Instruction	Symbol	Result

1. Valley fold (a series of short dashes): Fold inward.

2. Mountain fold (dash-dot-dash): Fold outward.

3. Prefold (two-headed arrow): Fold inward and outward.

4. Open (outlined arrow): Open the fold.

5. Turn over (arrow with loop): Turn the figure over.

6. Zigzag (zigzag arrow): Paper folded in accordion pleats.

7. Pull out (outlined arrow): Section pulled outward.

8. Combination fold: Consecutive valley and mountain folds (see page 6).

Combination Folds

A combination fold is several mountain and valley folds executed consecutively. There are numerous variations. Before you fold, make sure you know where the mountain and the valley folds are. The symbols presented to you on page 5 will help. Remember to always prefold all dotted lines. To follow are some examples of combination folds to practice. They will make folding our Origami figures easier for you. It will not hurt to try the same folds several times in a row.

Instructions and folding steps

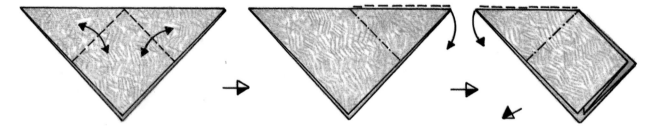

Prefold. Bend the right corner with valley and mountain fold inward; do the same for the left corner.

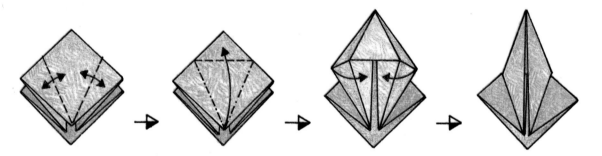

Prefold. Pull the lower corner of the square (with two mountain folds and one valley fold) upward. Fold the two corners onto the middle line.

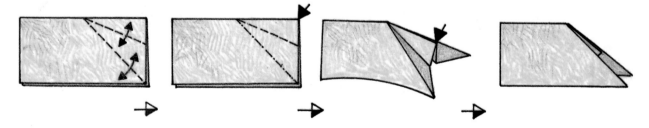

Prefold. Press the right corner with valley and mountain fold inward.

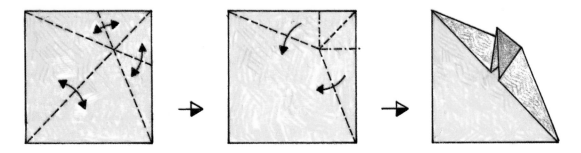

Prefold. Bend the corner with three valley and two mountain folds onto the middle line so it stands vertically upright.

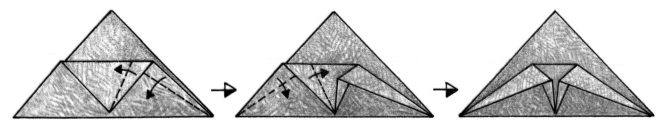

Bend the right corner with two valley folds; do the same for the left corner.

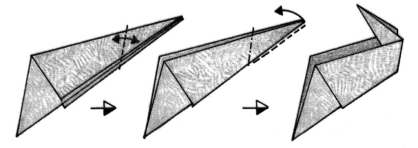

Prefold. Fold the tip inward with a valley and mountain fold.

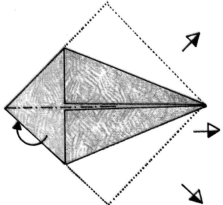

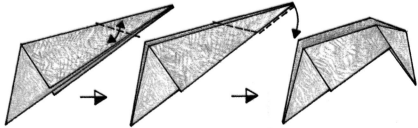

Prefold. Fold the tip over to the outside with two valley folds.

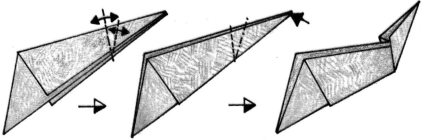

Prefold. Press the point with a valley and mountain fold upward and to the left.

7

Basic Form I

Basic Form I is the starting point for making the dragon boat, bird and hedgehog in this section. It is one of the most simple basic-forms in Origami.

The Dragon Boat is called this because it resembles a dragon rising out of the water. This traditional model is a good exercise for the more complicated models that will follow.

The Bird is only one example of the numerous bird models that exist in Origami. This figure is one of my favorites because of the elegance of its body.

The Hedgehog is not so easily reproduced in paper, although the body shape requires only a few details. The trickiest part is making the front legs in steps 15 to 17. Steps 22 to 26 are for simulating the spines.

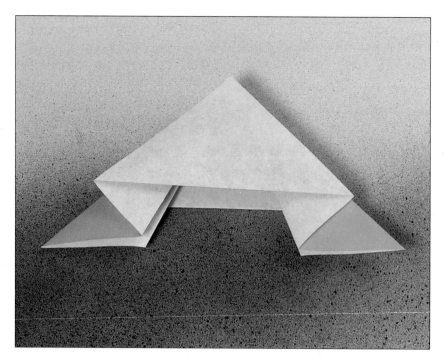

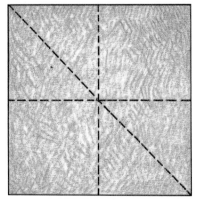

1. Prefold a square piece of paper at the dotted lines.

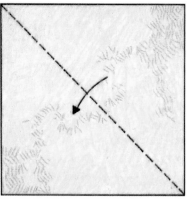

2. Fold the right upper corner onto the left lower one.

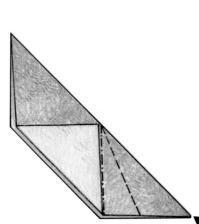

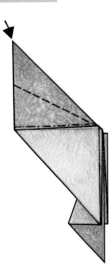

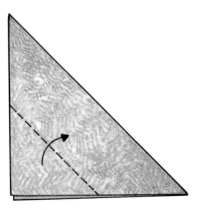

3. Bend the front and rear corners upward at the marking.

5. Push the right corner with a combination fold . . .

7. Repeat at the left corner.

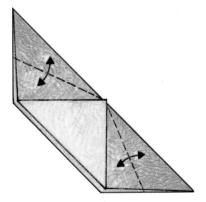

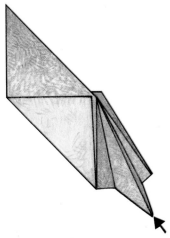

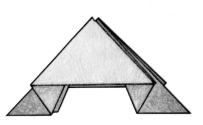

4. Prefold at the dotted lines.

6. . . . inward.

8. Completed Basic Form I.

Dragon Boat

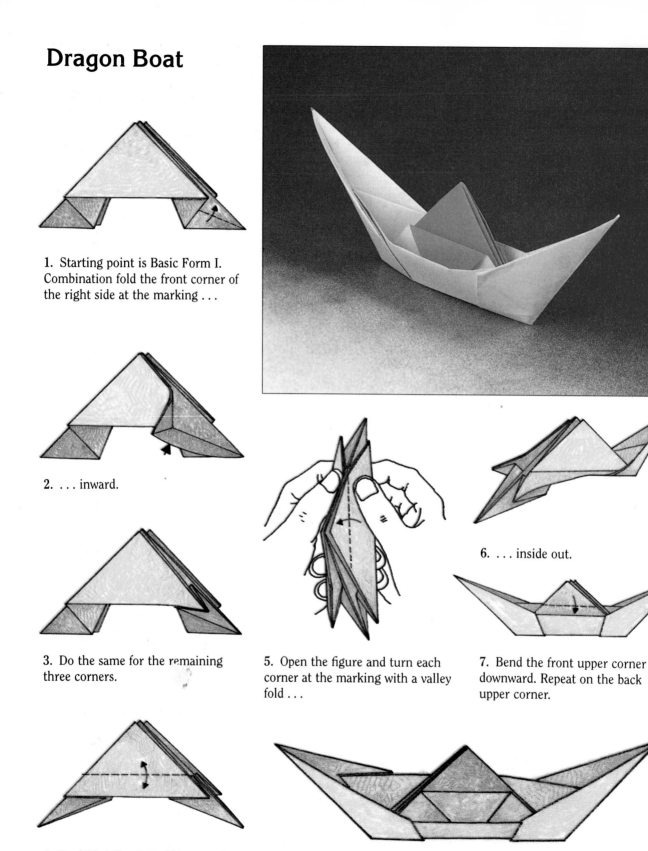

1. Starting point is Basic Form I. Combination fold the front corner of the right side at the marking . . .

2. . . . inward.

3. Do the same for the remaining three corners.

4. Prefold at the dotted lines on the front and back sides.

5. Open the figure and turn each corner at the marking with a valley fold . . .

6. . . . inside out.

7. Bend the front upper corner downward. Repeat on the back upper corner.

8. Completed dragon boat.

Bird

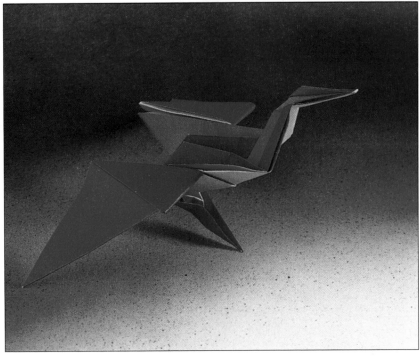

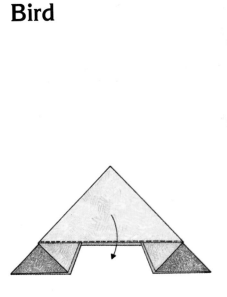

1. Starting point is Basic Form I. Fold the front and back downward with a valley fold.

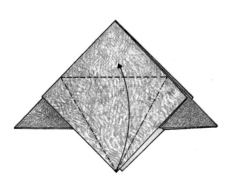

2. Pull the lower front tip upward . . .

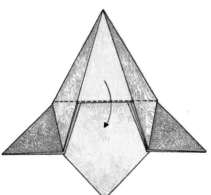

4. Bend this corner downward with a valley fold.

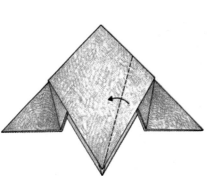

6. Valley fold so that the outer edge of the marked corner is placed onto the center axle. At the same time . . .

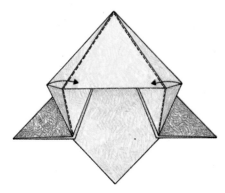

3. . . . and then fold in the side corners with a combination fold at the dotted lines.

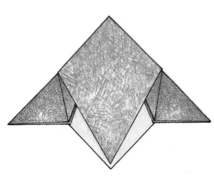

5. Repeat steps 2 to 4 on the back side.

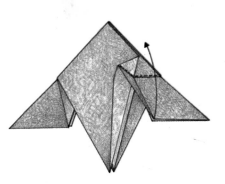

7. . . . fold the right part upward.

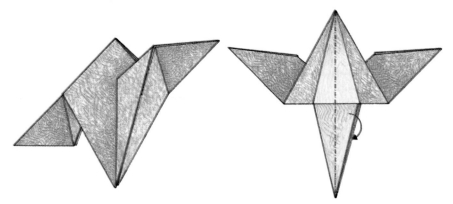

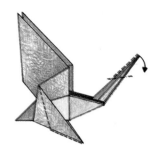

8. Repeat steps 6 and 7 on the left side.

12. Fold the figure in half.

14. Fold the right tip on the inside downward to get the head. Fold the lower tip with combination fold to the left.

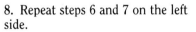

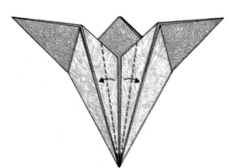

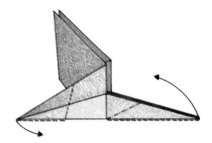

9. Bend outward the two inner edges.

13. Bend the right tip on the inside upward and the left tip on the outside downward with combination folds.

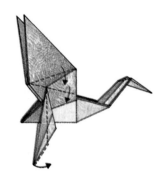

15. Fold the front and rear wings at the dotted lines. Bend the foot with a combination fold to the right.

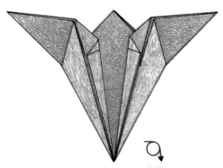

10. Turn the form over.

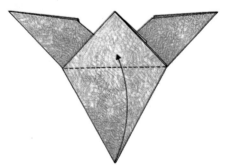

11. Fold upward the lower front tip.

16. Completed bird.

Hedgehog

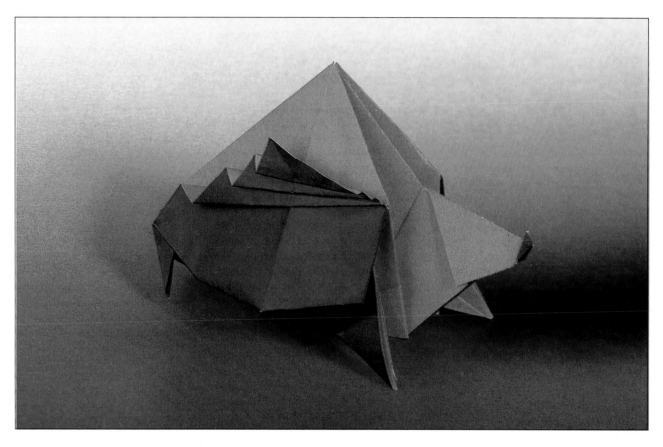

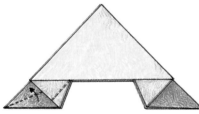

1. Starting point is Basic Form I. Fold the front left corner inward at the marking with a combination fold.

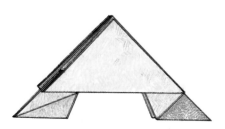

2. Repeat on the back side.

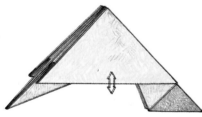

3. Open the bottom of the figure.

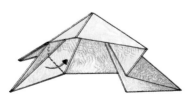

4. Bring the left lower tip under and . . .

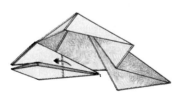

5. . . . valley fold at the dotted lines.

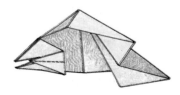

6. Close the figure back up.

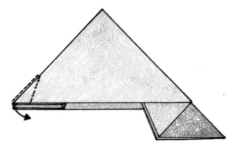

7. Fold the front and back left corners inward in order . . .

10. Fold the front and back corners toward the center at the marking.

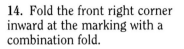

14. Fold the front right corner inward at the marking with a combination fold.

8. . . . to get the tail and two hind legs.

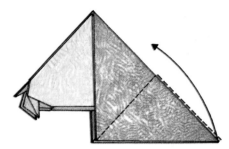

11. Bend the right corner upward with a combination fold and . . .

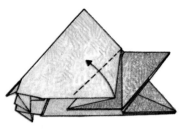

15. Valley fold and you get a small square.

9. Bend the front and back legs inward with a combination fold.

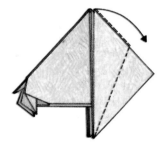

12. . . . pull it down again at the dotted lines.

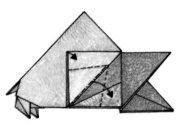

16. Prefold and pull the lower left corner forward. Tilt the upper left corner . . .

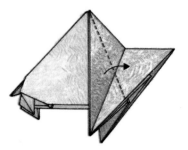

13. Fold the front and back middle corners to the right with valley fold.

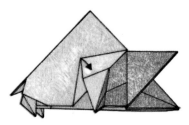

17. . . . diagonally downward.

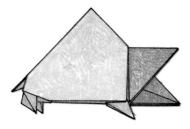

18. Repeat steps 14 to 17 on the back side.

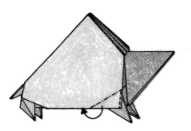

19. Combination fold the front and back corners inward at the marking.

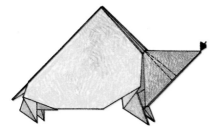

20. Press the neck inward with a combination fold.

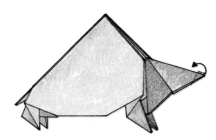

21. Bend the snout upward.

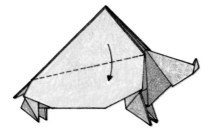

22.

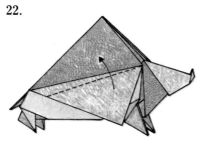

23.

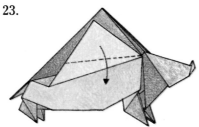

24.

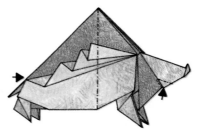

25.

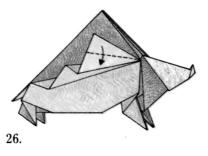

26.

22.–26. Bend the front flap with a valley fold at the dotted lines. Repeat on the back side.

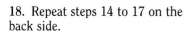

27. Form the head. Press the body slightly together at the center dotted lines.

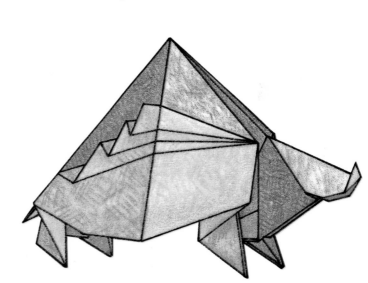

28. Completed hedgehog.

Basic Form II

Basic Form II, because of the way it looks, is often called "tea bud." It is the starting point for the sea horse.

The Sea Horse *is one of my most beautiful paper models whose special characteristic lies in the optimal use of the paper surface and edges. This figure can be considered to be representative of the principles of my art of paper folding.*

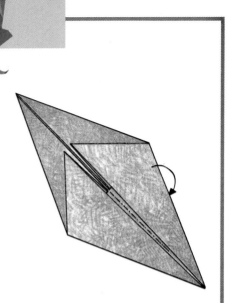

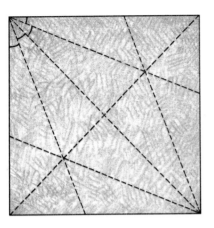

1. Prefold a square piece of paper at the dotted lines.

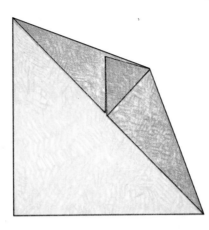

3. ... so that the corner stands vertically. Repeat on the opposite corner.

5. Fold the figure in half.

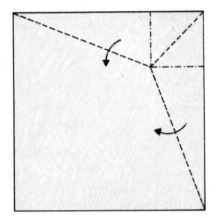

2. Turn the white side upward and combination fold . . .

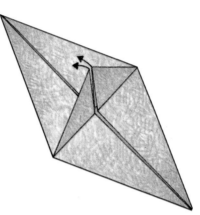

4. Tilt the two tips to the left.

6. Completed Basic Form II.

Sea Horse

1. Starting point is Basic Form II. Open to a triangle.

2. Fold the upper tip inward with a combination fold.

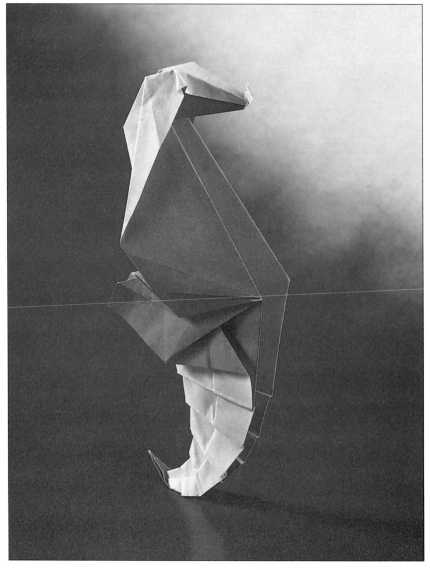

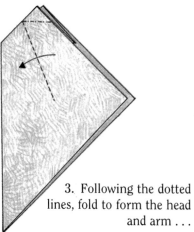

3. Following the dotted lines, fold to form the head and arm . . .

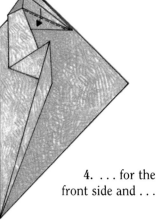

4. . . . for the front side and . . .

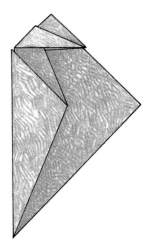

5. . . . then the back.

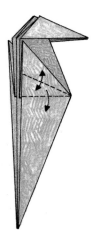

6. Prefold. Bend the tip at the marking with a valley fold so that it stands vertically forward.

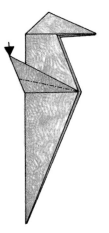

7. Press the tip.

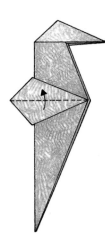

8. Valley fold.

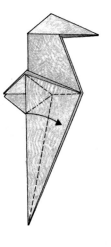

9. Fold the front left outer edge at the marking with a combination fold onto the right outer edge.

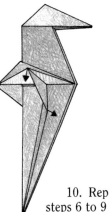

10. Repeat steps 6 to 9 on the back side.

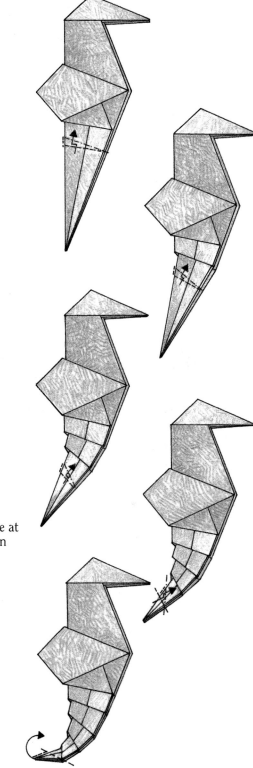

11. Make combination folds to either the left or right to form the tail.

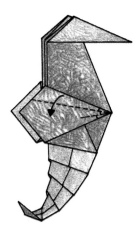

12. Bend the front upper corner at the dotted lines.

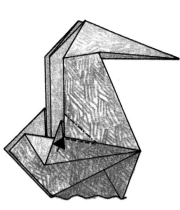

15. Press the tips inward . . .

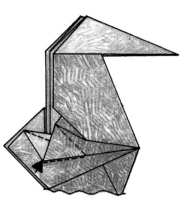

16. . . . as indicated.

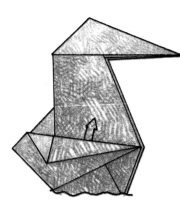

13. Pull out at the marking.

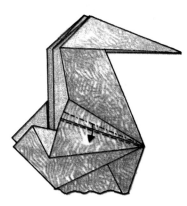

14. Bend downward with a combination fold.

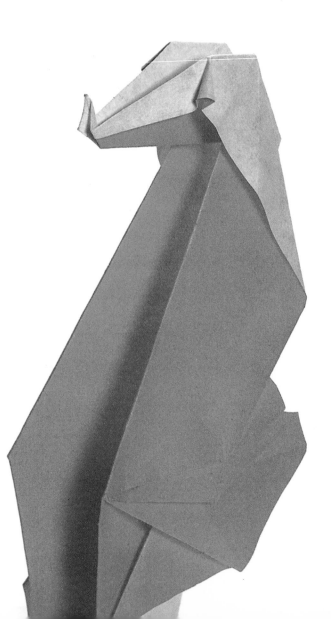

20

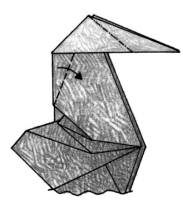

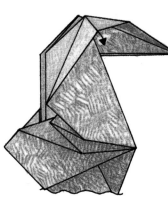

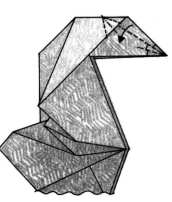

17. Fold the left upper corner with a combination fold . . .

18. . . . to the right.

19. Fold the upper corner downward so that a small, vertically standing corner comes out. This is the eye.

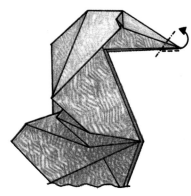

20. Repeat steps 12 to 19 on the back side. Fold up tip to form the snout.

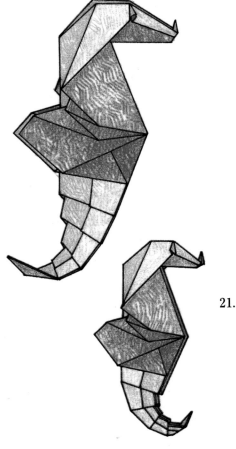

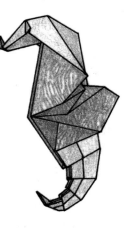

21. Completed sea horse.

Basic Form III

Basic Form III can be called a universal basic-form because many figures can be made from it. This is a good starting point for anyone who wants to create his or her own Origami figures.

The Eagle is the first example of what can be easily made out of this form. The most interesting and intricate part of this figure is the arrangement of the wing folds, which adds to its striking feature.

The Bear resembles a real one in its stance and the many folds and hanging tongue of its face. Steps 8 and 9 are the trickiest, so it is important to carefully follow the instructions and drawings in this part.

The Kangaroo is one of my favorite creations. Besides capturing its characteristics, I like the detail of this figure, down to the protruding pouch. The kangaroo figure is a popular motif among paper folders.

The Pig is another popular motif and not especially difficult to create. The many folding-steps make the body more three-dimensional.

The Dinosaur, the last of this group, is relatively easy to make as well. Step 17 can be skipped, depending on how you want the figure to look.

For beginners, I recommend using larger-format paper such as $8^{1}/_{2} \times 8^{1}/_{2}$ inches $(21 \times 21$ cm) for the eagle, kangaroo and pig.

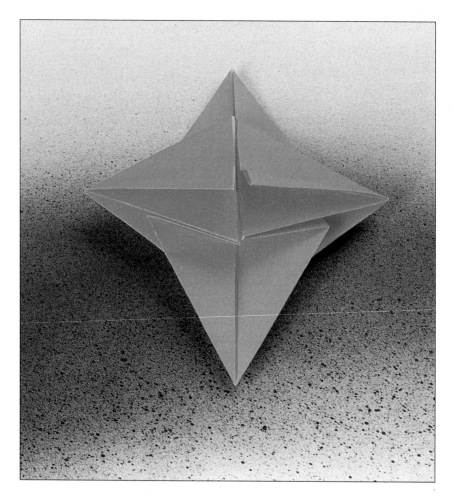

1. Prefold a square piece of paper at the dotted lines.

2. Turn the white side upward and valley fold.

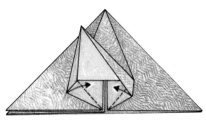

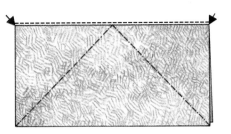

3. Fold the upper corners inward.

7. . . . upward and fold down sides.

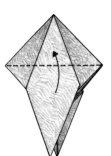

11. . . . bend only the front part up again.

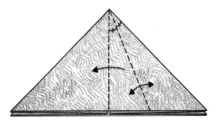

4. Prefold. Bend the front right corner to the left so that it stands vertically facing you.

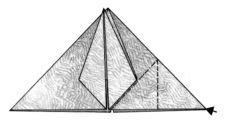

8. Repeat steps 4 to 7 on the back side. Press the right tip 90° inward with a combination fold.

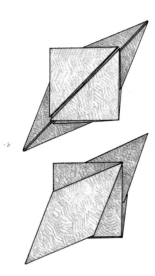

12. Completed Basic Form III.

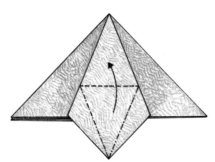

5. Press in the tip.

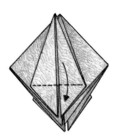

9. Repeat with the left tip.

6. Pull the lower corner with a combination fold . . .

10. Bend the front and back parts downward at the dotted lines, then . . .

Eagle

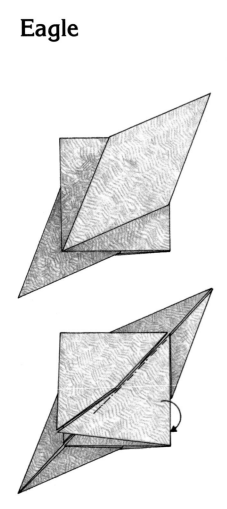

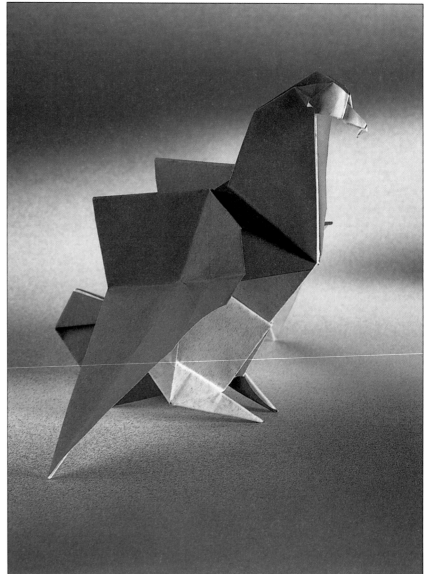

1. Starting point is Basic Form III with double-folded sides pointing downward. Fold the figure in half.

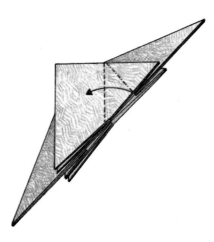

2. Fold in the corner at the marking with a combination fold . . .

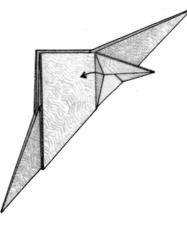

3. . . . to the left.

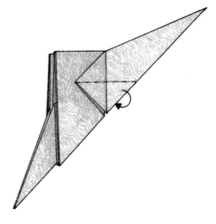

4. Bend the front corner inward at the marking.

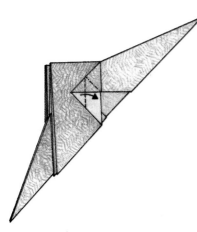

5. Fold the corner with a combination fold to the inside right.

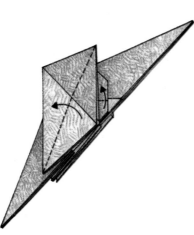

8. Fold open the wings with a combination fold as indicated.

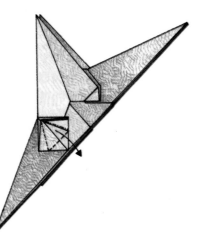

11. Pull down the front upper corner of the small diamond.

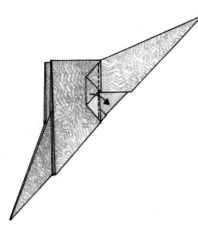

6. Valley fold.

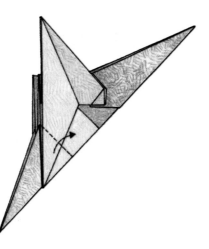

9. Repeat steps 2 to 8 on the back side. Bend the front corner upward so that it . . .

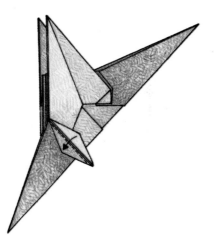

12. Fold the right side over to the left. Repeat steps 7 to 11 on the back side.

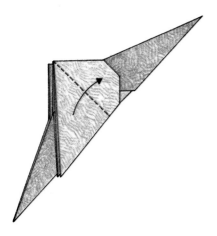

7. Valley fold so that the front left tip stands vertically facing you.

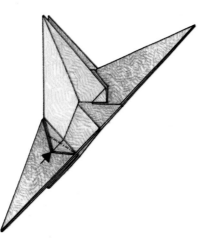

10. . . . stands vertically facing you. Press down to get a small diamond.

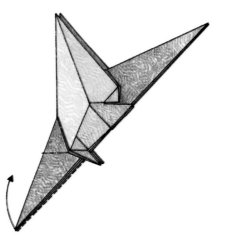

13. Fold the lower tip on the inside upward . . .

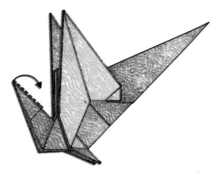

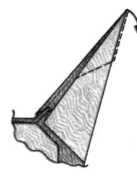

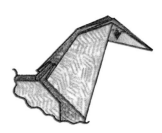

14. . . . and then on the outside downward.

17. Fold again at the dotted lines on the outside downward.

19. Combination fold so that a little vertically standing corner is made. Repeat on the back side.

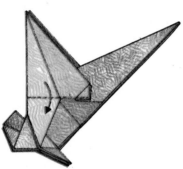

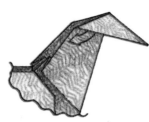

15. Bend the wings downward at the front and back.

18. Pull out and build up again to get the layer of white color.

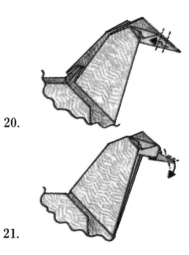

20.

21.

20.–21. Form the snout.

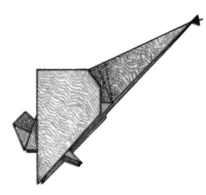

16. Press the upper tip on the outside downward.

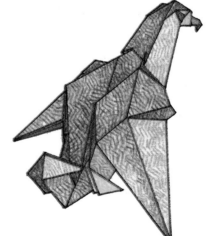

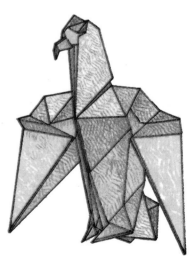

22. Completed eagle.

Bear

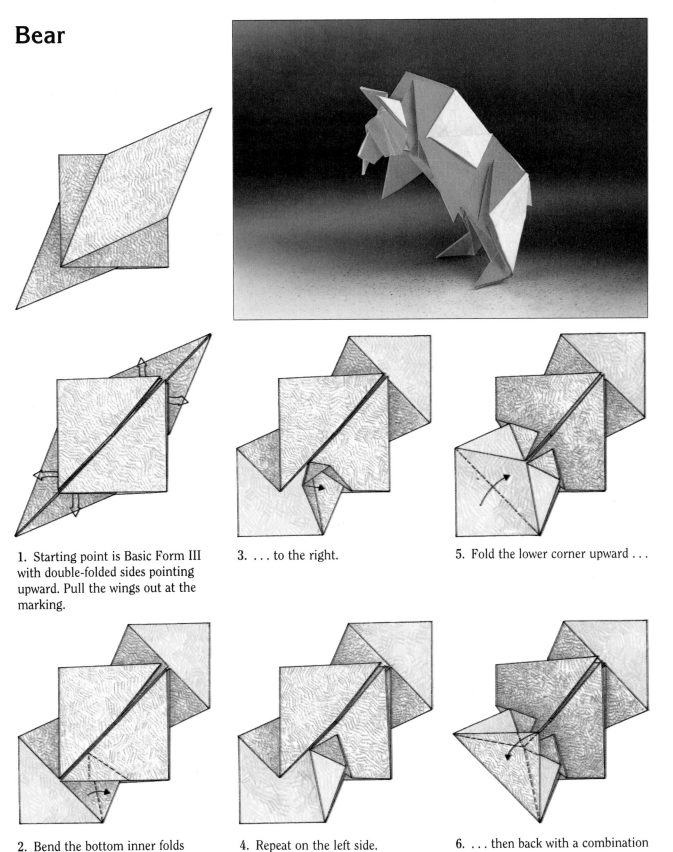

1. Starting point is Basic Form III with double-folded sides pointing upward. Pull the wings out at the marking.

2. Bend the bottom inner folds upward and . . .

3. . . . to the right.

4. Repeat on the left side.

5. Fold the lower corner upward . . .

6. . . . then back with a combination fold so that the corner stands vertically.

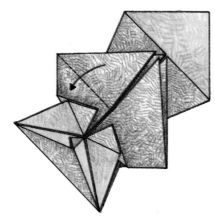

7. Valley fold so that the double fold stands vertically facing you.

8. Fold part of the center section upward with a combination fold.

9. Bring the front corner over the combination fold . . .

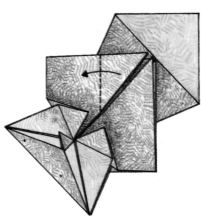

10. . . . and bend it to the left again.

11. Repeat steps 7 to 10 on the right side.

12. Fold the left and right corners on the inside downward.

13. Turn the figure over.

14. Valley fold at the dotted lines.

15. Fold the figure in half.

16. Press the bottom tip with a combination fold . . .

17. . . . inward.

18. Press the upper tip on the inside downward at the dotted lines.

19. Fold in the hanging sides for the front and back.

20. Bend the front and back sides with a valley fold.

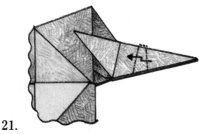

21.

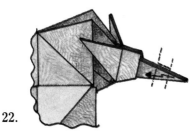

22.

21.–22. Form the head with a zigzag fold.

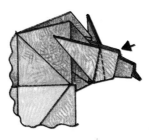

23. Press the head inward with a combination fold.

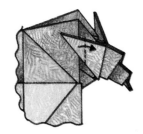

24. Bend the tips of the front and back with valley fold for the ears.

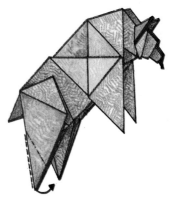

25. Fold the lower tips of the front and back on the inside upward with a combination fold.

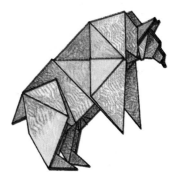

26. Completed bear.

Kangaroo

1. Starting point is Basic Form III with double-folded sides pointing downward. Pull out the wings as indicated.

2. Turn the figure over.

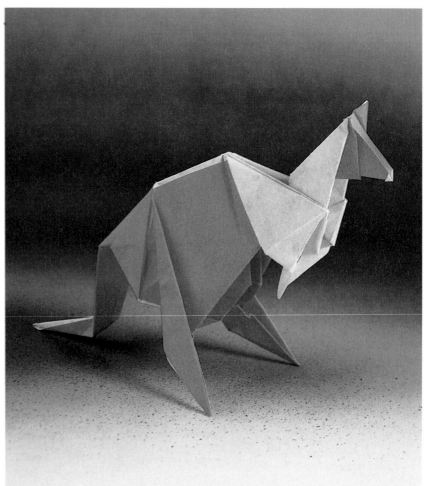

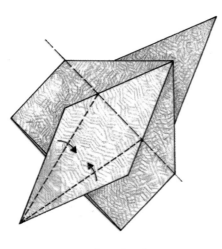

3. Fold the left and right corners along the dotted lines toward the center.

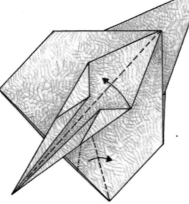

4. Bring the right side slightly over to the left so that the bottom layer . . .

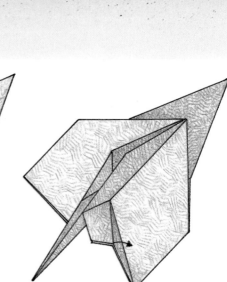

5. . . . can be folded upward with a combination fold.

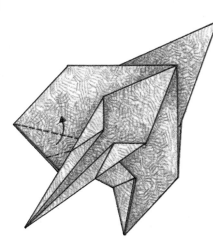

6. Repeat steps 4 and 5 on the left side.

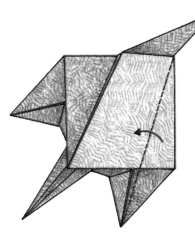

9. Fold the right corner to the left.

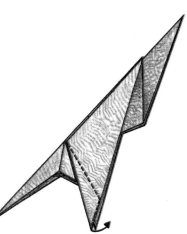

12. Bend the lower tips of the front and back to the outside upward.

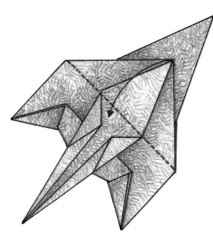

7. Valley fold.

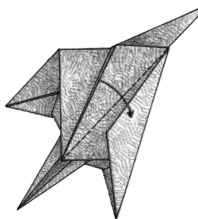

10. Fold the top layer back to the right again.

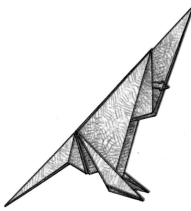

13. Pull out at the front and back as indicated.

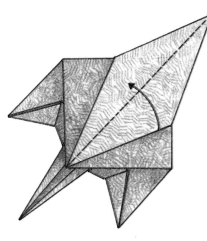

8. Fold the top layer over to the left.

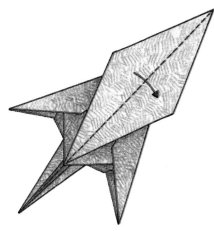

11. Repeat steps 8 to 10 on the left side. Fold the figure in half.

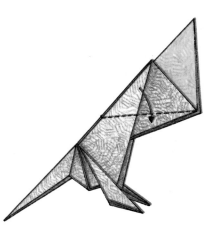

14. Valley fold at the front and back sides.

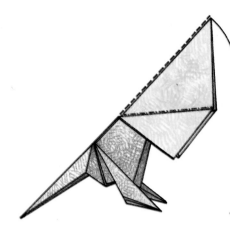

15. Fold the upper tip inside downward.

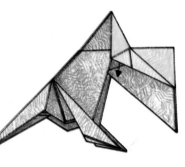

16. Open the front lower corner, then . . .

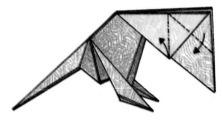

17. . . . fold the front upper corner downward.

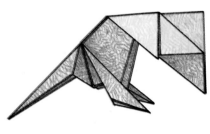

18. Close up. Repeat on the back side.

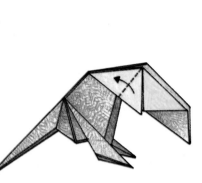

19. Fold both sides back as indicated.

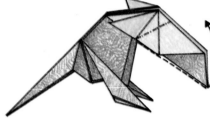

20. Fold the right tip inside upward along the dotted lines.

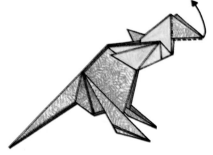

21. Fold part of it back inside downward . . .

22. . . . then up and . . .

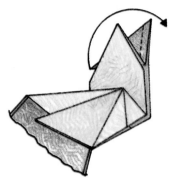

23. . . . once more down.

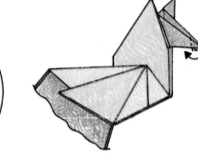

24. Form the snout by folding the tip back.

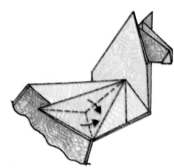

25. Fold the front flap with a combination fold to create a tip.

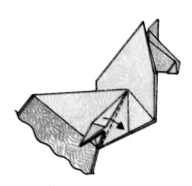

26. Valley fold to the right.

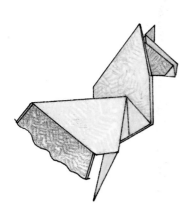

27. Repeat steps 25 and 26 on the back side.

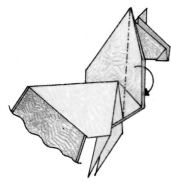

28. Fold inside for the front and back.

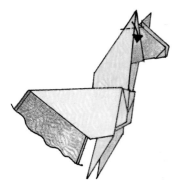

29. Form the ears with valley fold.

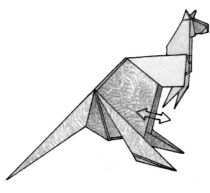

30. Open the figure at the marking.

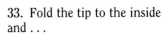

31. Bend the front layer to the right.

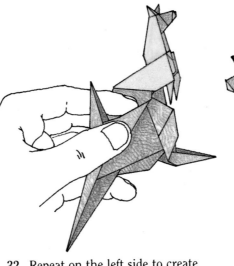

32. Repeat on the left side to create the pouch.

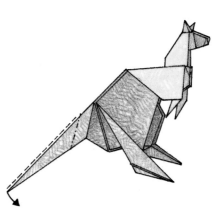

33. Fold the tip to the inside and . . .

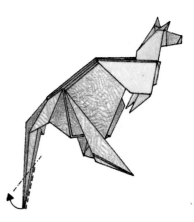

34. . . . then out.

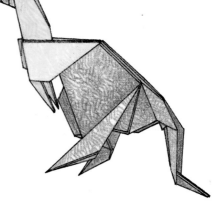

35. Completed kangaroo.

Pig

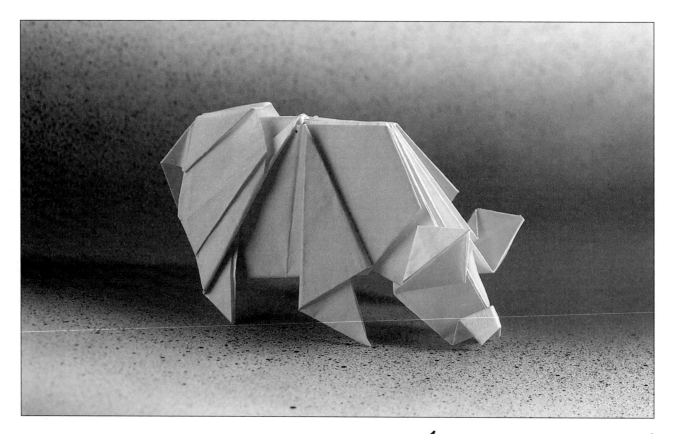

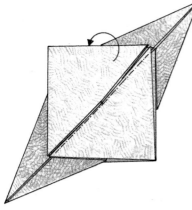

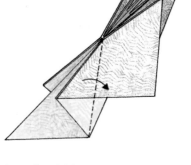

1. Starting point is Basic Form III with double-folded sides pointing upward. Fold the figure in half.

2. Pull out wing at the marking for the front and back.

3. Valley fold at the front and back sides.

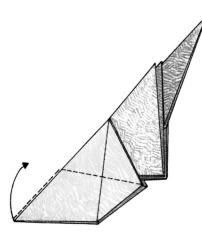

4. Fold the tip on the outside upward.

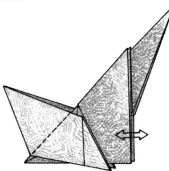

5. Open the entire figure so that the tip stands vertically.

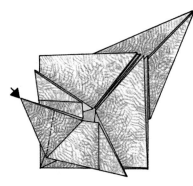

6. Press in the tip.

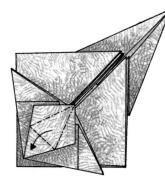

7. Pull the top corner with a combination fold . . .

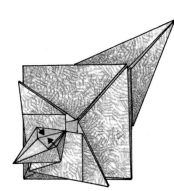

8. . . . downward.

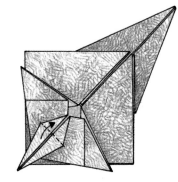

9. Valley fold upward.

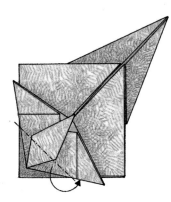

10. Valley fold the lower half of the corner under.

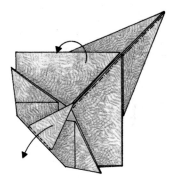

11. Hold the front tip down, then fold the figure in half.

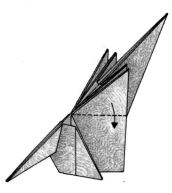

12. Fold downward and . . .

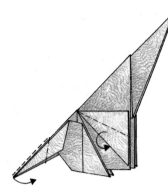

13. . . . then inward at the dotted lines. Repeat steps 12 and 13 on the back side. Fold in the tail.

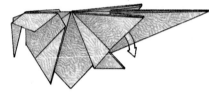

15. Fold the front layer to the inside. Repeat steps 14 and 15 on the back side.

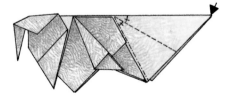

16. Press the right corner inward at the dotted lines.

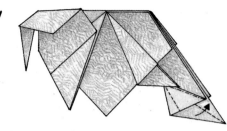

17. For the front and back, fold the corners inside upward at the marking.

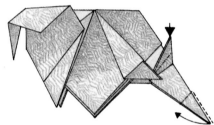

18. Valley fold so that the tip stands vertically forward.

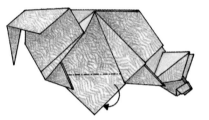

19. Press the tip to create the ear. Repeat steps 18 and 19 on the back side. Bend the right tip inward and then . . .

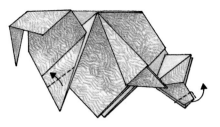

20. . . . fold on the outside upward to get the snout. For the hind leg, fold upward, then . . .

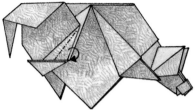

21. . . . inward with a mountain fold. Repeat on the back side.

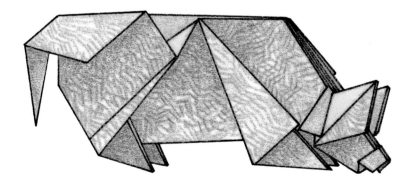

22. Fold in the front and back corners.

23. Completed pig.

Dinosaur

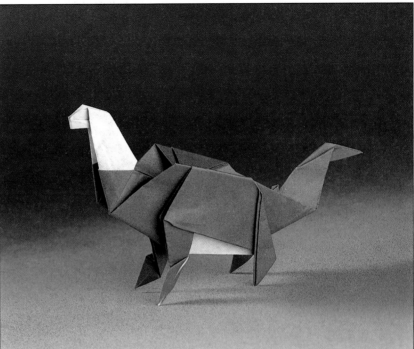

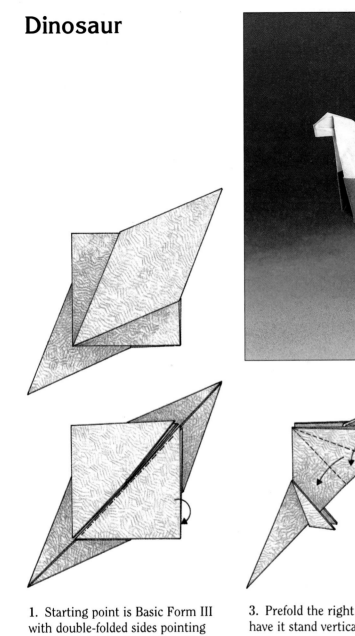

1. Starting point is Basic Form III with double-folded sides pointing upward. Fold the figure in half.

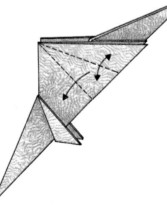

3. Prefold the right flap and then have it stand vertically facing you.

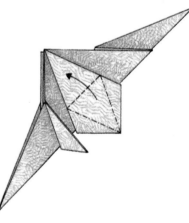

5. Pull the front corner with a combination fold . . .

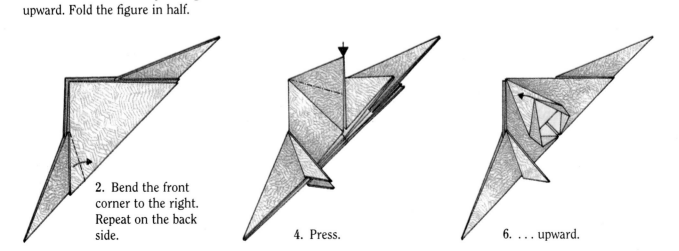

2. Bend the front corner to the right. Repeat on the back side.

4. Press.

6. . . . upward.

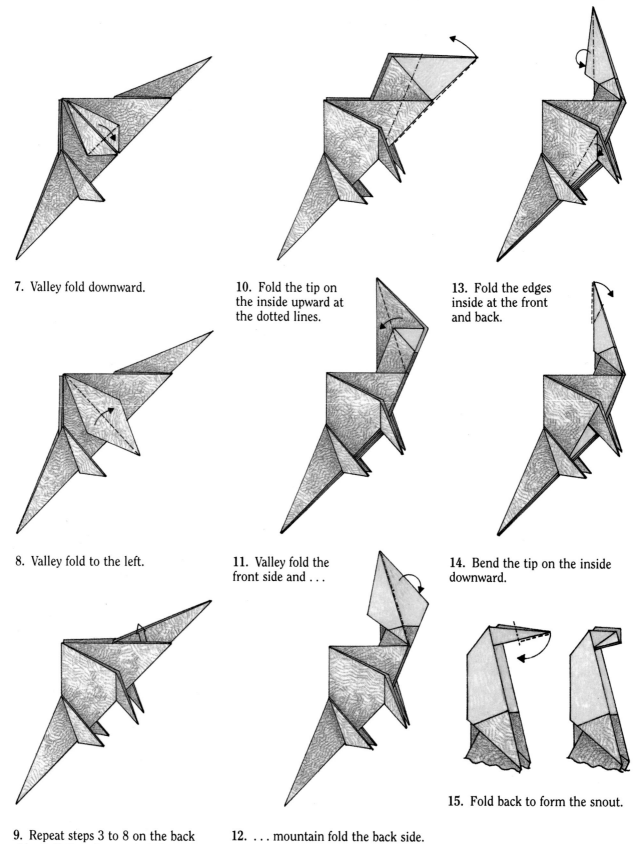

7. Valley fold downward.

8. Valley fold to the left.

9. Repeat steps 3 to 8 on the back side. Pull the wings out at the marking in the front and back.

10. Fold the tip on the inside upward at the dotted lines.

11. Valley fold the front side and . . .

12. . . . mountain fold the back side.

13. Fold the edges inside at the front and back.

14. Bend the tip on the inside downward.

15. Fold back to form the snout.

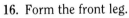

16. Form the front leg.

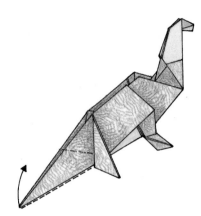

18. Bend the tip of the tail inside upward . . .

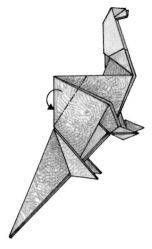

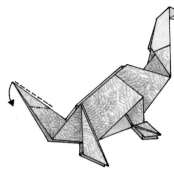

19. . . . and again downward.

17. Fold inside the front and back humps.

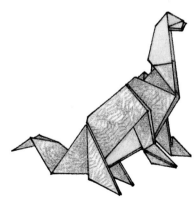

20. Completed dinosaur.

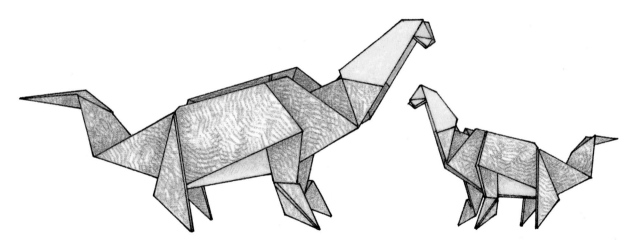

Basic Form IV

I developed Basic Form IV specifically to make the butterfly figure in this book. There are two ways to develop a paper figure. The most common way is to work with a basic form and (sometimes accidentally) create an animal form. The second method is to look for, or to newly develop, a special basic form for a desired figure. This butterfly comes from the second method.

The Butterfly in this book differs from the other known butterfly models by its three-dimensional body and two feelers, which emphasize its special charm and beauty. Pay special attention to steps 7, 8 and 9 when folding.

The Bee comes from the butterfly figure and is also one of my favorite models.

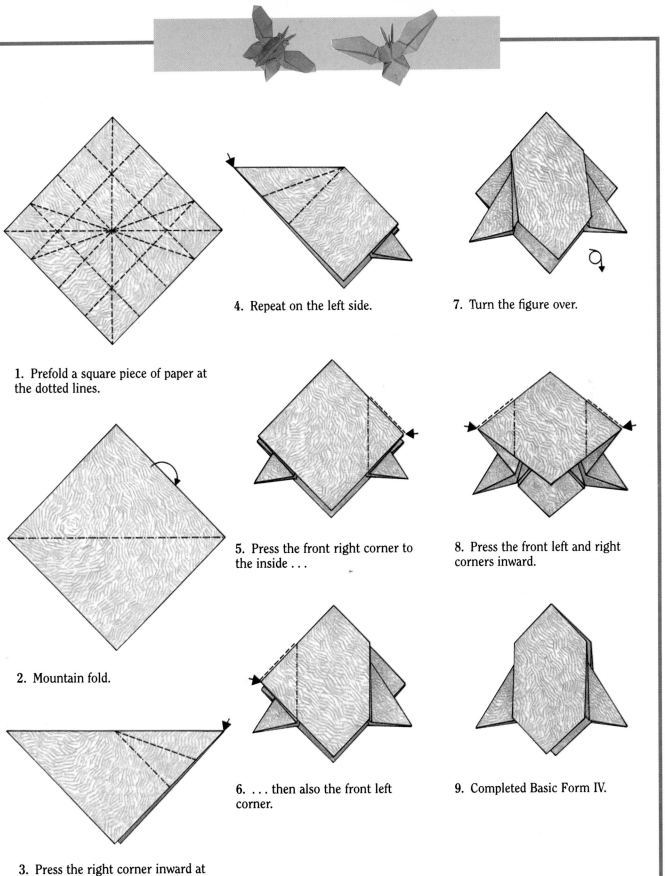

1. Prefold a square piece of paper at the dotted lines.

2. Mountain fold.

3. Press the right corner inward at the dotted lines.

4. Repeat on the left side.

5. Press the front right corner to the inside . . .

6. . . . then also the front left corner.

7. Turn the figure over.

8. Press the front left and right corners inward.

9. Completed Basic Form IV.

Butterfly

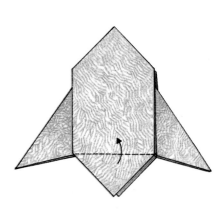

1. Starting point is Basic Form IV. Bend the front lower corner upward.

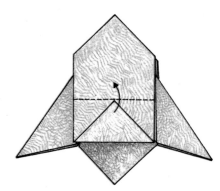

2. Fold the front double-layer upward.

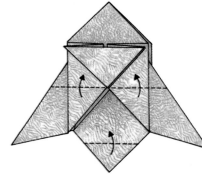

4. Valley fold as indicated.

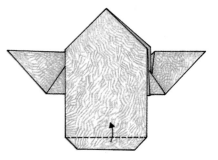

6. Valley fold.

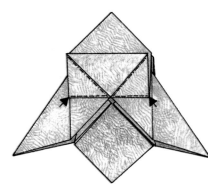

3. Press the left and right corners inside.

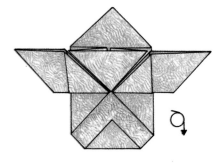

5. Turn the figure over.

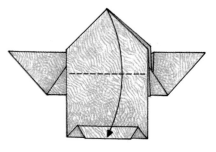

7. Bend the upper corner downward with a valley fold.

8. Fold the front left and right parts toward the center. At the same time . . .

9. . . . bend the left and right corners of the outer wings upward.

10. Fold out the left and right wingtips. Fold in the two edges toward the center.

11. Bend the left and right corners down.

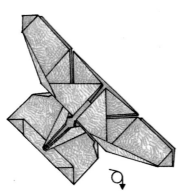

12. Turn the figure over.

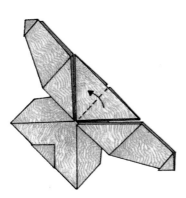

13. Bring up the upper right corner so that it stands vertically.

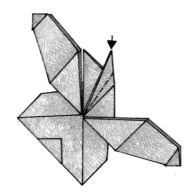

14. Press.

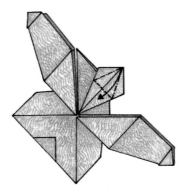

15. Pull the top corner downward with a combination fold.

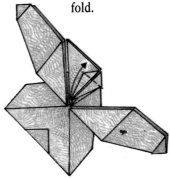

16. Valley fold upward . . .

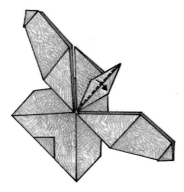

17. . . . then valley fold to the right. Repeat steps 13 to 17 on the upper left corner.

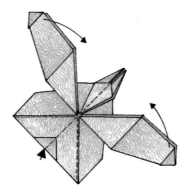

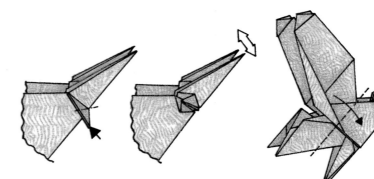

18. Fold the figure in half, then press inward at the marking.

20. Press to create an eye. Repeat steps 19 and 20 on the back side. Open the upper part of the figure a little.

22. Bend the four wings down at the front and back, then . . .

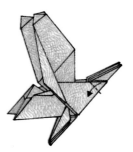

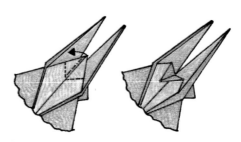

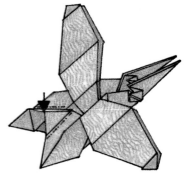

19. Valley fold so that a small corner stands vertically.

21. Pull the center tip down and close the figure.

23. . . . press the center corner down at the marking so that it lies flat on the rear wings.

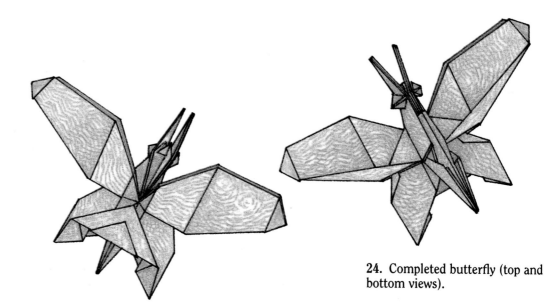

24. Completed butterfly (top and bottom views).

Bee

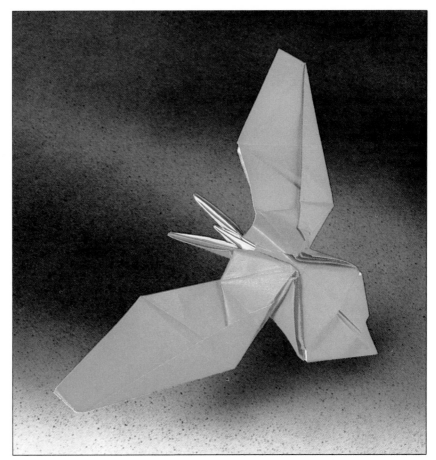

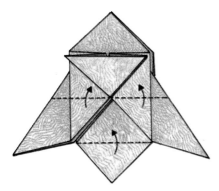

1. Starting point is step 4 of the butterfly. Valley folds.

2. Turn the figure over.

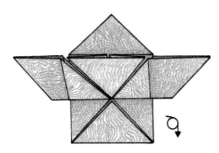

3. Bend the upper corner downward with valley fold.

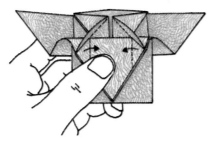

4. Fold the front left and right parts toward the center. At the same time . . .

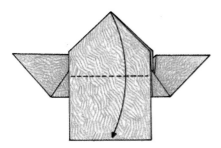

5. . . . bend the left and right corners of the outer wings upward.

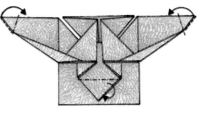

6. Fold in the left and right wing-tips. Fold the front center piece under with a mountain fold.

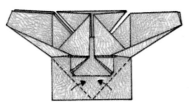

7. Fold the left and right corners upward so that they are tucked under the center piece.

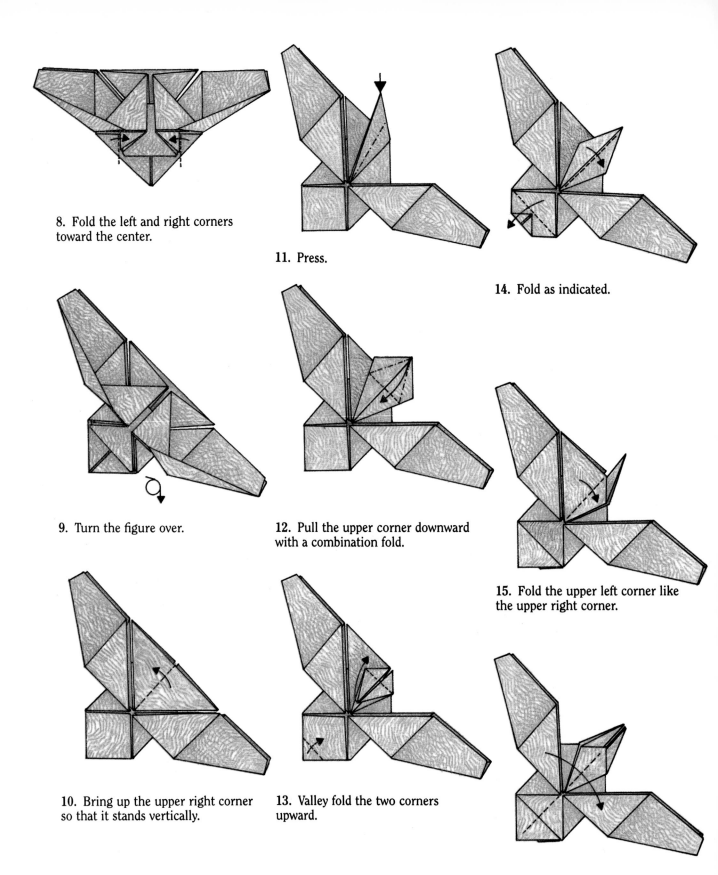

8. Fold the left and right corners toward the center.

11. Press.

14. Fold as indicated.

9. Turn the figure over.

12. Pull the upper corner downward with a combination fold.

15. Fold the upper left corner like the upper right corner.

10. Bring up the upper right corner so that it stands vertically.

13. Valley fold the two corners upward.

16. Fold the figure in half.

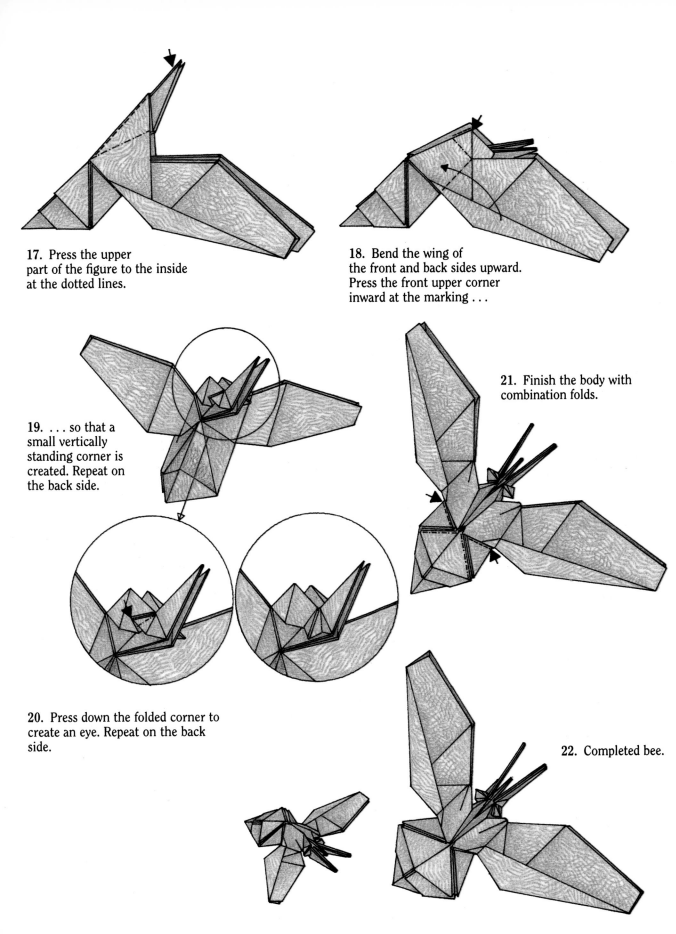

17. Press the upper part of the figure to the inside at the dotted lines.

18. Bend the wing of the front and back sides upward. Press the front upper corner inward at the marking . . .

19. . . . so that a small vertically standing corner is created. Repeat on the back side.

20. Press down the folded corner to create an eye. Repeat on the back side.

21. Finish the body with combination folds.

22. Completed bee.

Basic Form V

I developed Basic Form V specifically for a lion figure. In contrast to the mostly symmetrical basic forms, the greater part of the folds are concentrated on the side from which the head is made.

The Dachshund, developed out of the lion, is a good warm-up exercise before progressing on to the next project.

The Lion is one of the most difficult figures. In many books it is put together with two individual pieces, which contradicts the principles of classic Origami. Therefore, it was especially important for me to develop this lion out of one piece of paper. Carefully follow the instructions when folding the head.

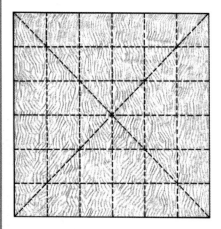

1. Prefold a square piece of paper at the dotted lines.

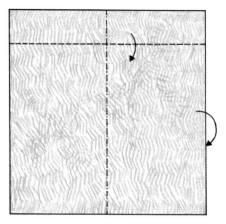

2. Turn the white side upward. Bend the upper part down, then fold the entire piece backward in half.

3. Bring the upper left corner downward with a combination fold.

4. Repeat this step on the back side.

6. Bend the front right fold . . .

8. Repeat steps 5 to 7 on the back side.

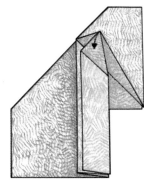

7. . . . back to the inside left to make it double.

9. Completed Basic Form V.

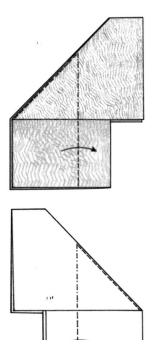

5. Bend the front left fold to the inside right.

Dachshund

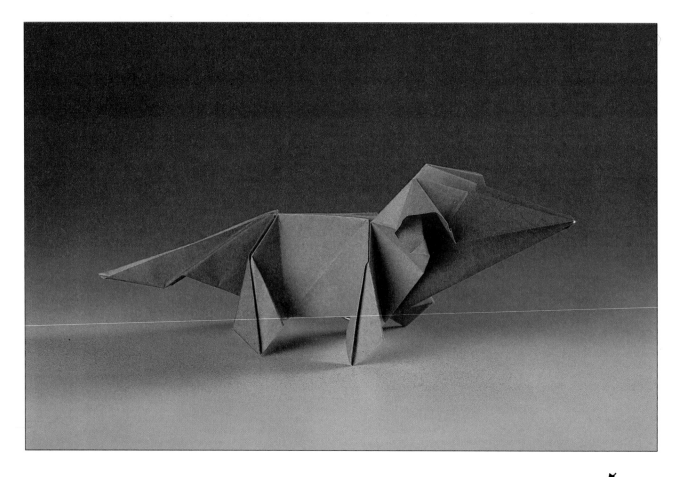

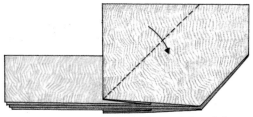

1. Starting point is Basic Form V. Bend the front upper left corner downward . . .

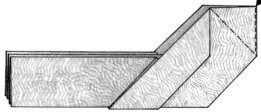

3. Press the corner inward at the dotted lines.

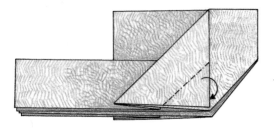

2. . . . then under with a mountain fold. Repeat on the back side.

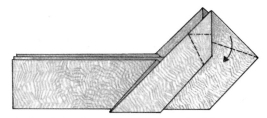

4. Bend the front part downward with a combination fold so that a small vertically standing corner is created.

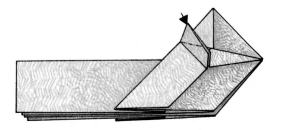

5. Press down to create an eye.

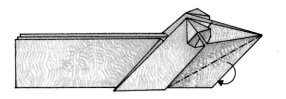

6. Repeat steps 4 and 5 on the back side.

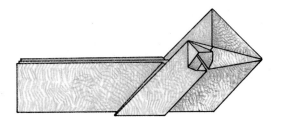

7. Bend the front and back corners inside at the marking.

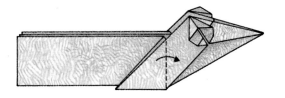

8. Fold to the right.

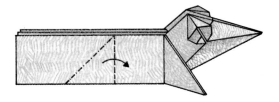

9. Fold along the dotted line to bring the front layer a little out.

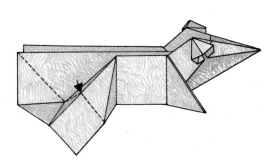

10. Press down as indicated.

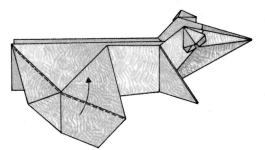

11. Valley fold upward so that the under side is flattened on the outside.

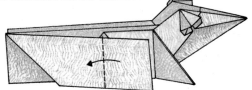

12. Valley fold to the left.

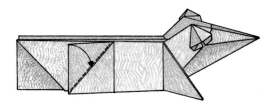

13. Bend the front upper corner inward.

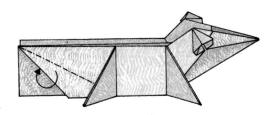

14. Fold the front lower corner under.

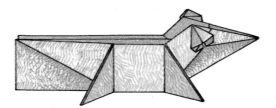

15. Repeat steps 8 to 14 on the back side.

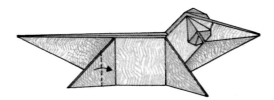

16. Fold the front left corner to the right at the dotted lines so that the tip stands vertically facing you.

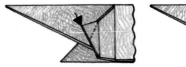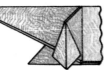

17. Press to make a leg. Repeat steps 16 and 17 for the three other legs.

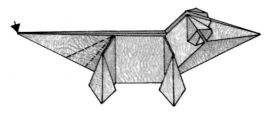

18. Press the tail inward with a combination fold.

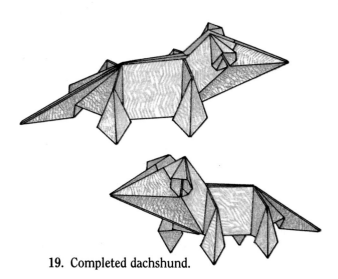

19. Completed dachshund.

Lion

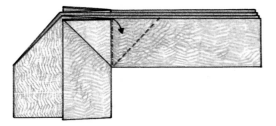

1. Starting point is Basic Form V. Make a valley fold at the front and back.

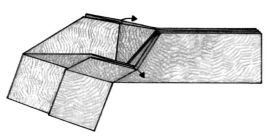

2. Pull the front and back sides down at the marking . . .

3. . . . so that the left part of the figure tilts upward.

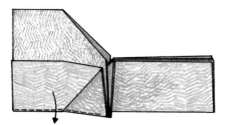

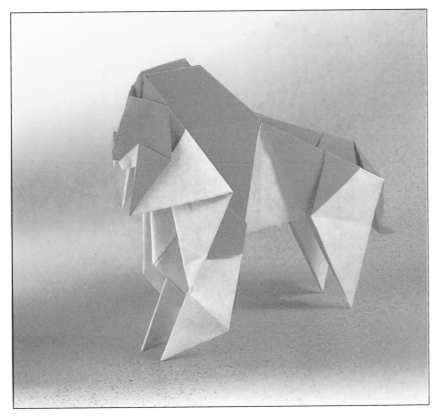

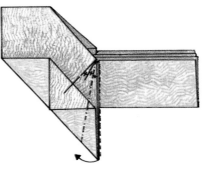

9. Fold the lower tips of the front and back inside along the dotted lines.

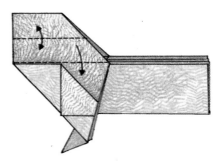

10. Prefold. Then push the top half down.

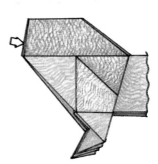

11. Open the left side of the double-fold, then . . .

12. . . . stick your finger inside and . . .

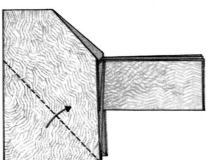

5. Fold the corners upward at the front and back and . . .

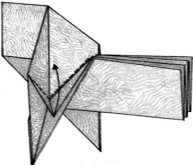

7. Open the front part of the figure a little bit toward the front.

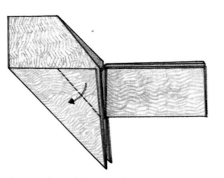

6. . . . then down again.
Note: If you use white paper, you do not need this step.

8. Bend the inner corner upward. Repeat on the back side.

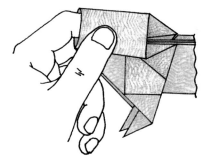

13. . . . make a new fold.

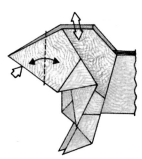

17. Open the upper part of the figure a little bit. Stick your finger in at the marked spot . . .

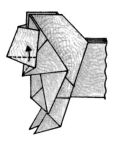

21. Bend the front and back corners upward with a combination fold.

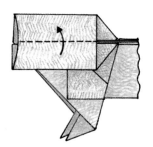

14. Valley fold upward.

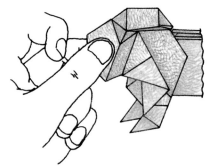

18. . . . so that the tip flattens out.

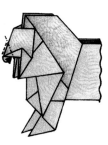

22. For the snout, fold the tip inward.

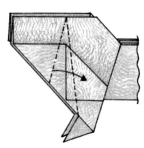

15. Fold the front part to the right with a combination fold.

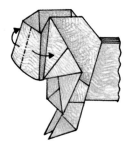

19. Bend according to the marking, then close back the upper part of the figure.

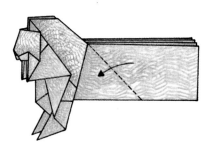

23. Open the front right layer to the left.

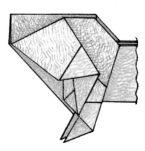

16. Repeat on the back side.

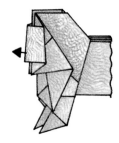

20. Pull the edge a little bit out.

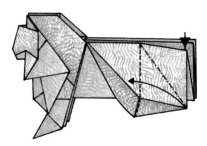

24. Fold the wings as indicated.

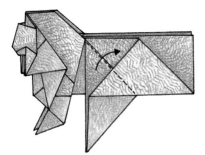

25. Fold the bottom upward and . . .

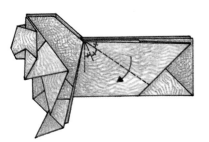

26. . . . then bend at the dotted lines downward.

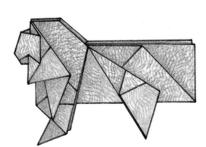

27. Repeat steps 23 to 26 on the back side.

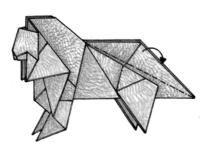

28. Fold the front and rear corners to the inside.

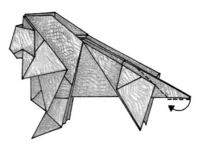

29. Bend the right tip on the outside downward . . .

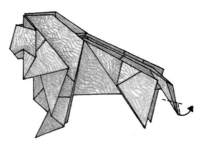

30. . . . then on the outside upward to get the tail.

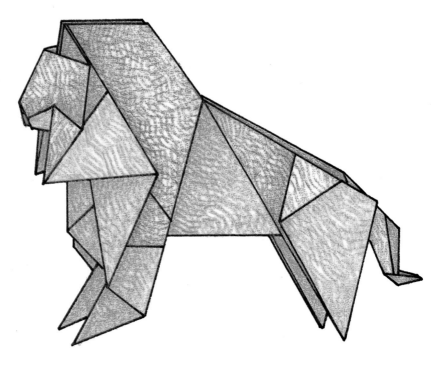

31. Completed lion.

Basic Form VI

I developed Basic Form VI in order to fold a frog figure. The important element of this form is that it already contains the frog's nose in its shape.

The Frog *in this book has a special liveliness through its folded eyes. Its limbs are made from a simple folding technique. You can also learn many other folding tricks when creating this figure.*

The Lobster *comes out especially three-dimensional when folding from this basic form. Follow steps 11 to 13 carefully in creating the head.*

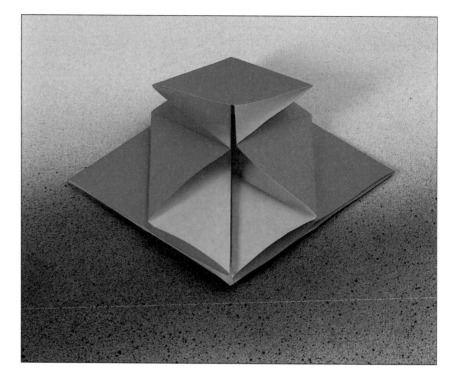

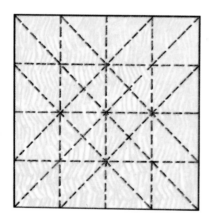

1. Prefold a square piece of paper at the dotted lines.

2. Turn the white side upward. Fold diagonally.

3. Press the corners inward with a combination fold.

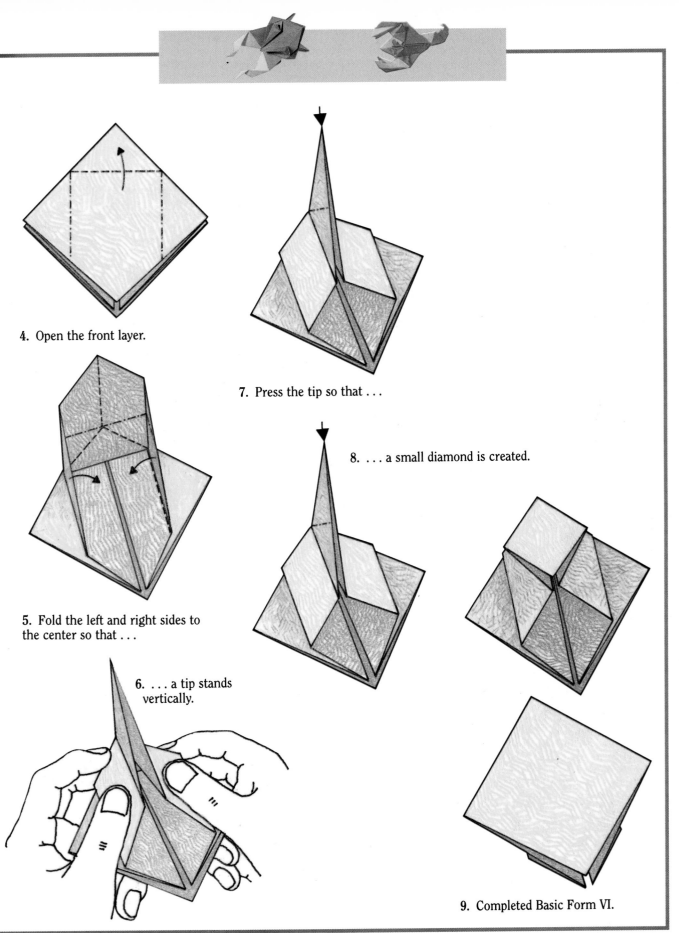

4. Open the front layer.

7. Press the tip so that . . .

8. . . . a small diamond is created.

5. Fold the left and right sides to the center so that . . .

6. . . . a tip stands vertically.

9. Completed Basic Form VI.

Frog

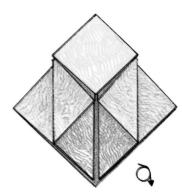

1. Starting point is Basic Form VI. Turn the figure over.

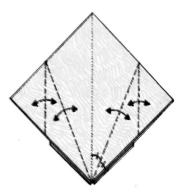

2. Prefold at the dotted lines.

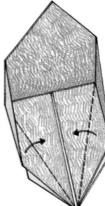

4. Fold the front left and right sides toward the center.

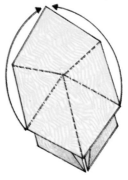

6. Bend upward and back the front left and right sides with a combination fold so that a vertically standing tip is created.

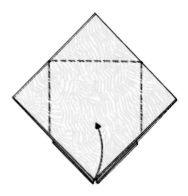

3. Open the front layer as indicated.

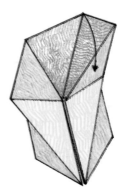

5. Fold the front part downward.

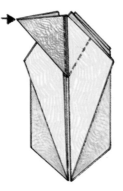

7. Push the tip backward with a combination fold so that . . .

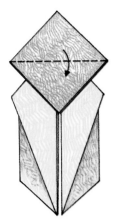

8. . . . a diamond is created. Valley fold.

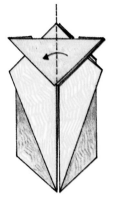

9. Fold the front right layer to the left.

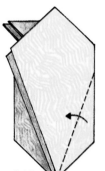

10. Valley fold.

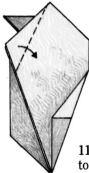

11. Fold the front corner to the right, then . . .

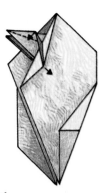

12. . . . the upper corner downward at the marking.

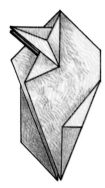

13. Repeat steps 9 to 12 on the left side.

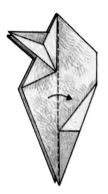

14. Fold the front left part of the figure to the right and . . .

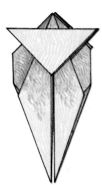

15. . . . the back right side to the left.

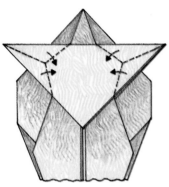

16. Fold the front corners with a combination fold so that vertically standing tips are created.

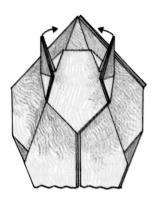

17. Bend the tips upward.

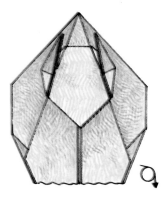

18. Turn the figure over.

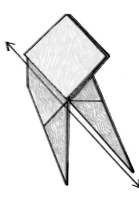

21. . . . as indicated.

25. Fold the front of the double layers to the left so that a corner stands vertically forward.

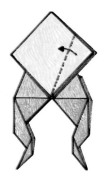

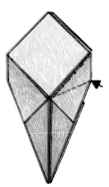

19. Press the right corner at the marking with a combination fold . . .

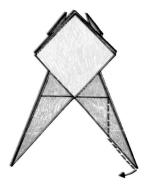

22. Repeat steps 19 to 21 on the left side. Fold the right lower tip to the outside left and . . .

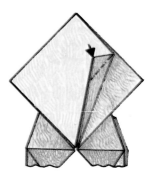

26. Press.

20. . . . inward . . .

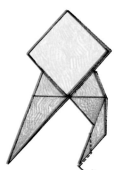

23. . . . then to the right again.

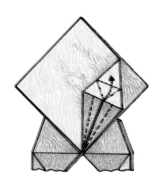

27. Pull the front layer at the marking with a combination fold . . .

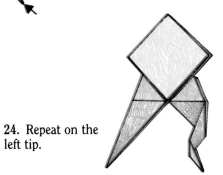

24. Repeat on the left tip.

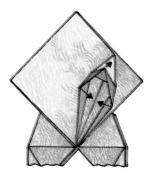

28. . . . upward.

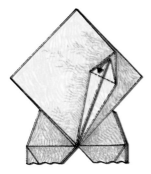

29. Bend the corner a little bit downward.

Lobster

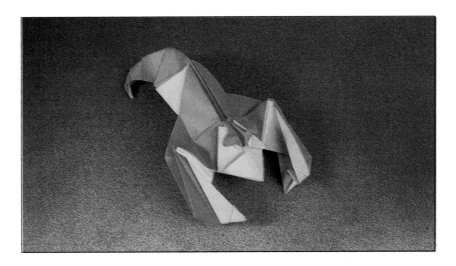

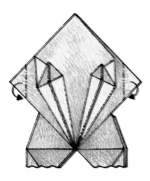

30. Repeat steps 25 to 29 on the left side. Bend the outer corners down.

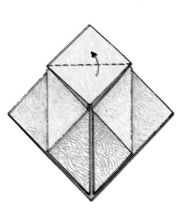

1. Starting point is Basic Form VI. Fold the front layer upward.

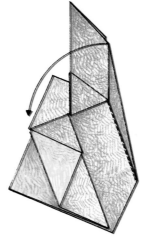

3. Fold to the left as indicated.

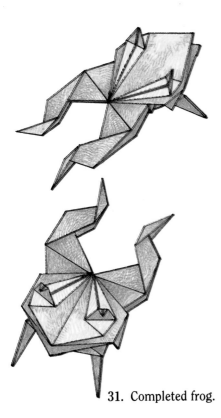

31. Completed frog.

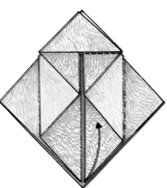

2. Bend the top right side of the double layer upward so that it stands vertically.

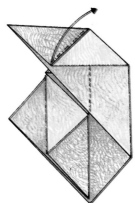

4. Fold the top layer to the right at the marking with a combination fold.

61

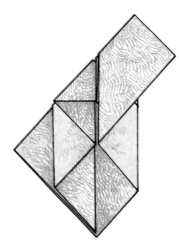

5. Repeat steps 2 to 4 on the left side.

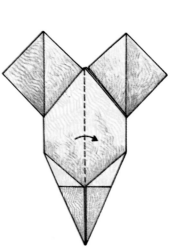

8. Fold the figure in half.

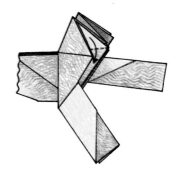

11. Bend the inner fold down at the marking. Repeat on the back side.

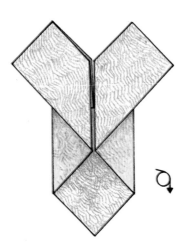

6. Turn the figure over.

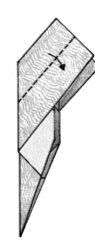

9. Bend the top half down for the front and back.

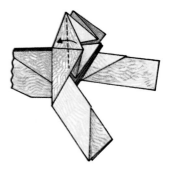

12. Fold the corner to the left for the front and back.

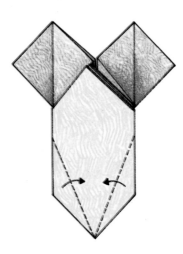

7. Fold the left and right outer corners to the center.

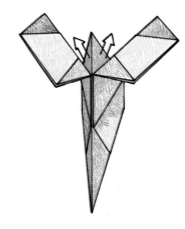

10. Pull out at the marking as indicated.

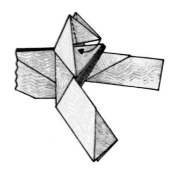

13. Press the corner inside.

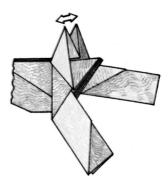

14. Open the two upper tips.

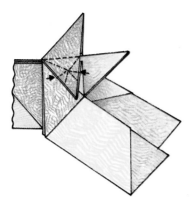

15. Press at the marking.

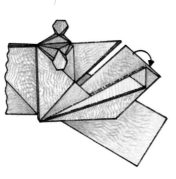

19. . . . back layers down.

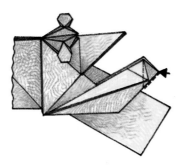

20. Press the corner in.

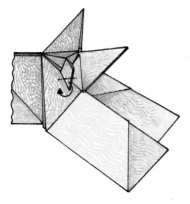

16. Bend the front tip backward to get an eye. Repeat steps 15 and 16 on the back side.

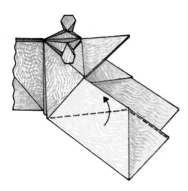

17. Bend the lower layer on the outside upward.

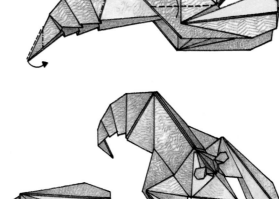

21. Repeat steps 17 to 20 on the back side. Press the back part of the figure to the inside.

22. Zigzag fold to form the body.

23. Fold the tip to the inside.

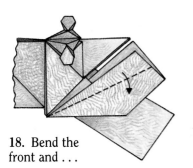

18. Bend the front and . . .

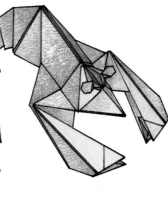

24. Completed lobster.

Basic Form VII

Basic Form VII offers the basis for the snake and caterpillar, whose shapes—which appear to be very simple—are difficult to reproduce on paper because it must replicate their lively and continuous forms. For this reason, these types of animals are rarely found in current Origami books.

The elegance of **The Snake** and **The Caterpillar** in this book are best reproduced through the arrangement of their body folds. Steps 5 and 6 of the caterpillar require an especially smooth touch.

1. Prefold a square piece of paper at the dotted lines.

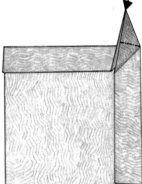

3. . . . you get a vertical tip. Press it down to make a small square.

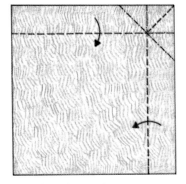
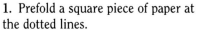

2. Turn the white side upward. Combination fold so that . . .

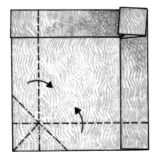

4. Repeat steps 2 and 3 at the left lower corner.

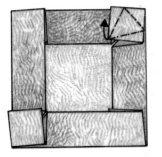

5. Pull the open corner of the upper small square with a combination fold . . .

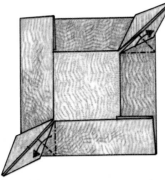

8. Open the two corners at the marking as indicated.

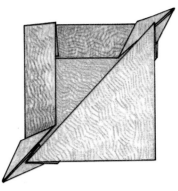

11. Repeat steps 8 to 10 on the left side.

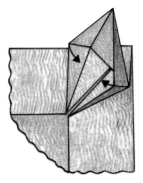

6. . . . upward.

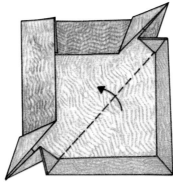

9. Fold up along the dotted lines and . . .

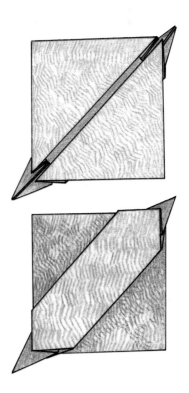

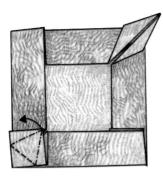

7. Repeat on the lower square.

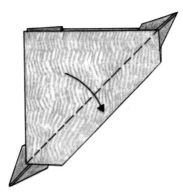

10. . . . then back down.

12. Completed Basic Form VII.

Snake

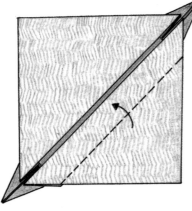

1. Starting point is Basic Form VII. Fold the front right corner up.

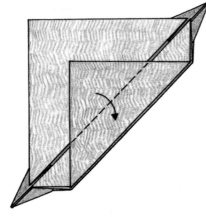

2. Fold back down . . .

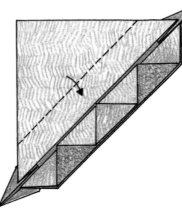

4. Repeat on the upper left corner.

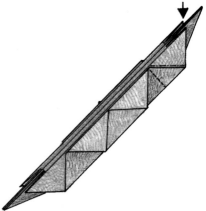

6. Press the upper part of the figure on the outside downward with a combination fold.

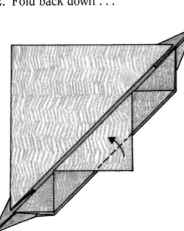

3. . . . and up again.

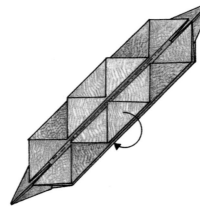

5. Fold the figure in half.

7. Open the figure a little bit.

8. On the left and right, fold in as indicated.

11. The top and side views of the figure.

9. Repeat down the body at the marking.

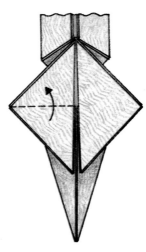

12. At the head of the figure, fold the front lower corner upward so that it . . .

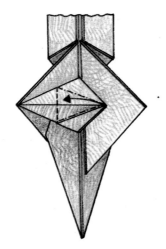

14. Pull the corner to the left with a combination fold.

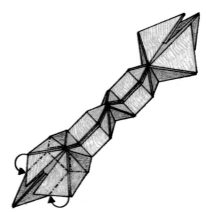

10. At the end of the figure, bend the left and right folds under.

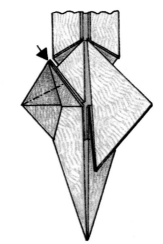

13. . . . stands vertically forward. Press.

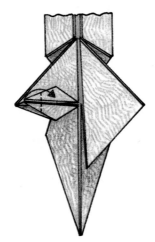

15. Fold at the dotted line to the right.

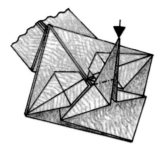

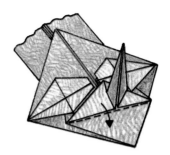

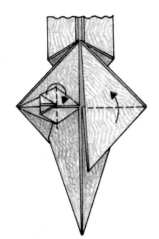

16. Fold once more. Repeat steps 12 to 16 on the right side.

19. Press the tip.

21. Valley fold down so that . . .

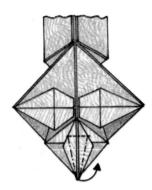

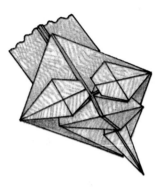

20. Pull the tip upward with a combination fold.

22. . . . the head of the snake has a tongue.

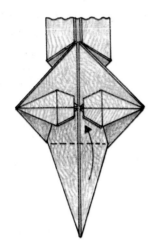

17. Bend the tip upward.

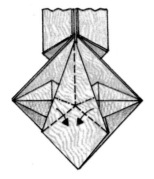

18. Fold the left and right sides to the center so that a vertically standing tip is created.

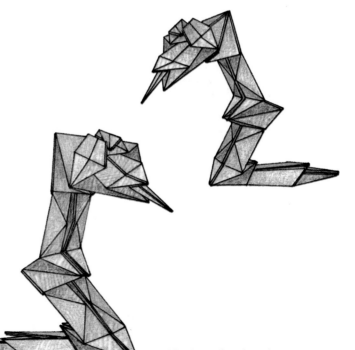

23. Completed snake.

Caterpillar

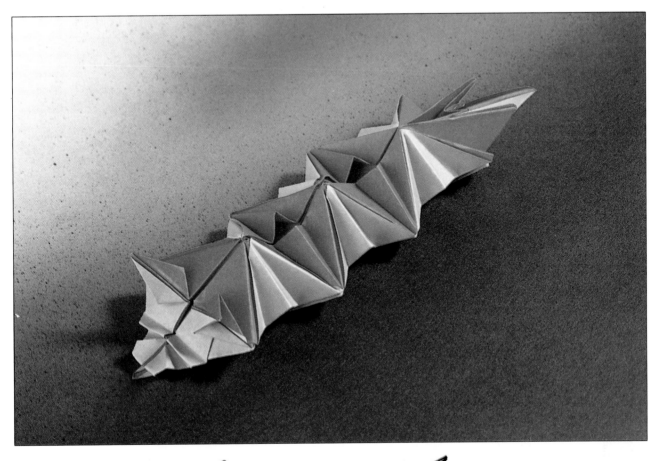

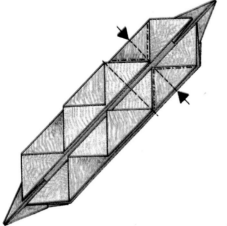

1. Starting point is step 5 of the snake. Press the left and right sides back.

2.

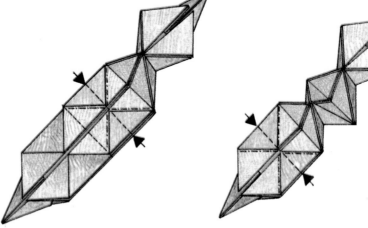

2. and 3. Repeat along the body.

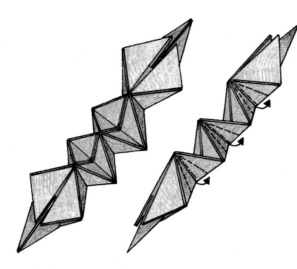

4. The top and side views of the figure. Pull out the left and right sides of the corners at the marking.

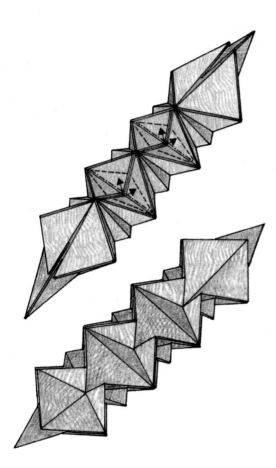

5. Pull up the left and right sides of the center sections.
The lower picture is the view from below.

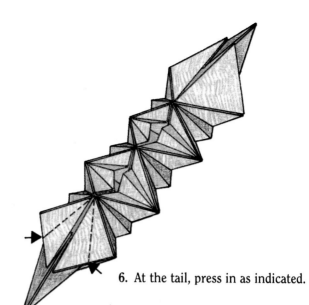

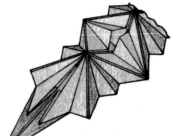

6. At the tail, press in as indicated.

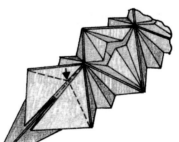

7. This is the back part of the caterpillar.

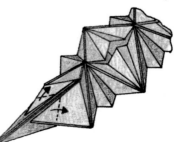

8. At the head of the figure, press in at the marking.

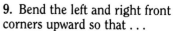

9. Bend the left and right front corners upward so that . . .

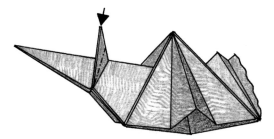

10. . . . they stand vertically. Press.

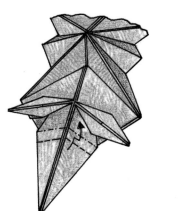

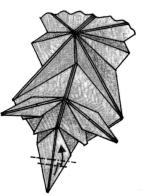

13. Zigzag fold at the dotted lines. 15. Zigzag fold.

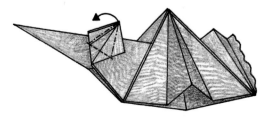

11. Pull down the upper corner
with a combination fold.

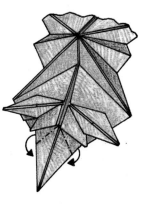

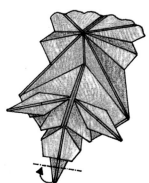

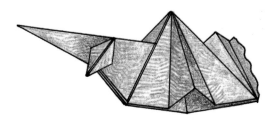

12. Repeat on the opposite side.

14. Bend the left and right sides
a little back at the marking. 16. Fold the tip under.

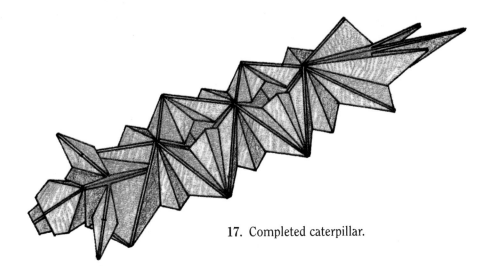

17. Completed caterpillar.

Basic Form VIII

Basic Form VIII offers the best basis for making many-legged animals. In my first book, I presented a spider. In this one, I am adding the crab and the ant. I originally tried to develop the crab out of the spider form, but I could not create the eyes. Therefore, I developed this basic form in order to create that feature.

The Crab is one my best creations. Once you have successfully folded its basic form, the rest of the steps should not be very difficult.

The Ant requires special attention when making the head.

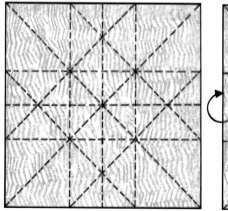

1. Prefold a square piece of paper at the dotted lines.

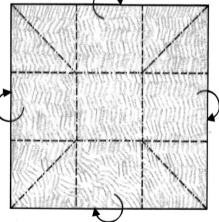

2. Fold the paper in as indicated for the left and right, top and bottom.

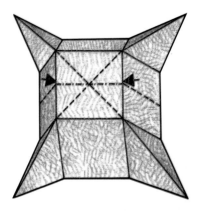

3. Press in the left and right layers toward the center at the marking.

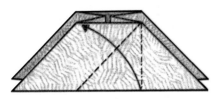

4. Fold the front layer to the left upward so that . . .

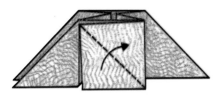

5. . . . a square is created. Valley fold upward.

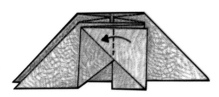

6. Valley fold to the left.

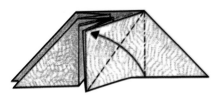

7. Repeat steps 4 to 6 on all sides so that way . . .

8. . . . a figure resembling an "X" is created. Turn the figure over.

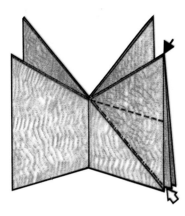

9. Open the right front part of the figure at the marking, then press the upper tip down in between so that three little tips are created.

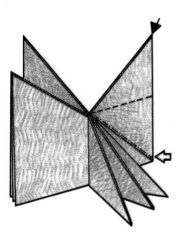

10. Repeat for the remaining three sides.

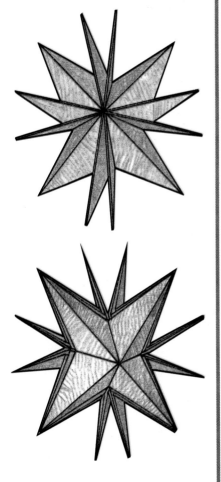

11. Completed Basic Form VIII with twelve tips.

Crab

1. Starting point is Basic Form VIII (view from top and bottom). Pull in the left and right tips to the center.

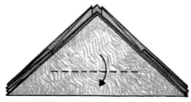

3. Open the front side and . . .

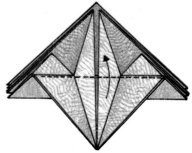

5. Fold up only the front layer.

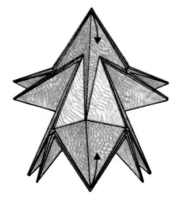

2. Fold the front and back tips to the center to make a flat triangle.

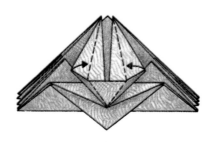

4. . . . fold in at the dotted lines as indicated.

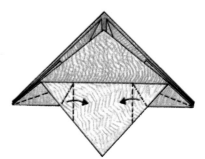

6. Combination fold the left and right sides toward the center.

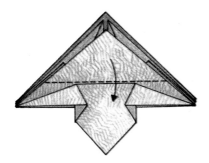

7. Fold the front upper layer downward again.

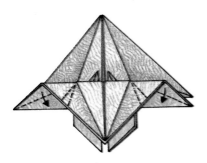

11. Turn the figure over.

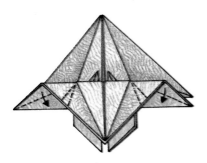

15. Fold both corners down with a combination fold.

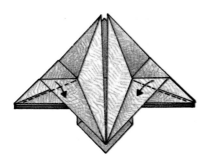

8. Bend the front corners downward.

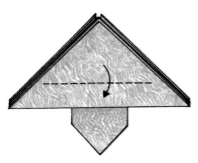

12. Repeat steps 3 to 10 on this side.

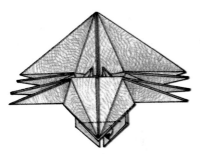

16. Valley fold under for the shield.

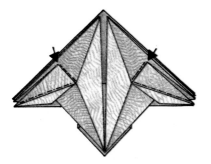

9. Press both corners on the inside downward at the marking.

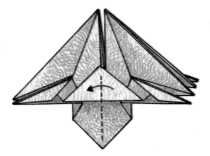

13. Bend the front right part of the figure to the left, the back left part to the right.

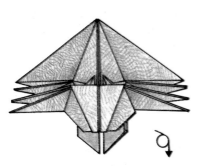

17. Turn the figure over.

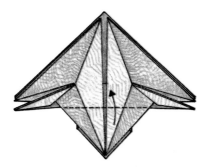

10. Fold the front layer upward at the dotted line.

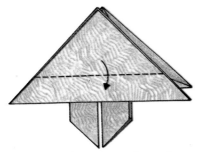

14. Fold the front upper layer down to get the eyes.

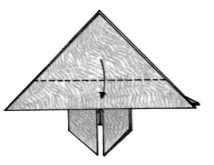

18. Fold the upper layer down . . .

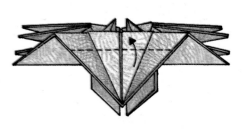

19. . . . and fold only the front layer up at the marking again.

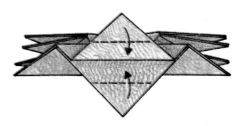

20. Bend the top and bottom corners toward the center.

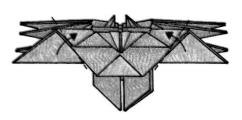

21. Bend the left and right tips upward for the claws.

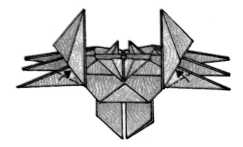

22. For the legs, tilt upward both front little tips.

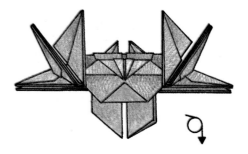

23. Turn the figure over.

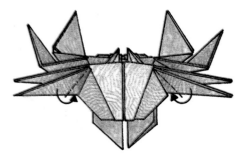

24. Fold the left and right front tips downward.

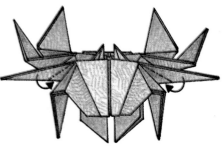

25. Repeat step 24.

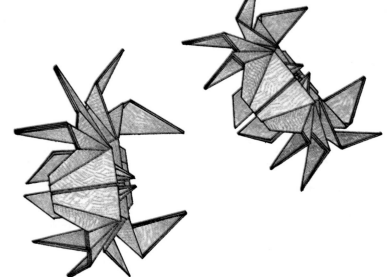

26. Completed crab.

Ant

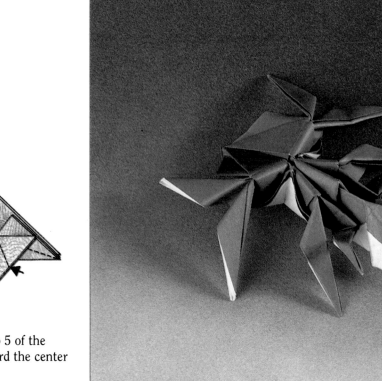

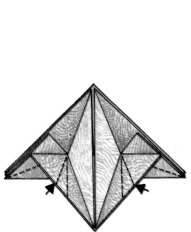

1. Starting point is step 5 of the crab. Press inward toward the center on the left and right.

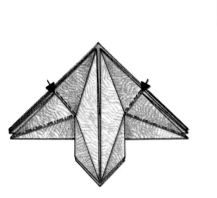

2. Press the left and right corners on the inside down.

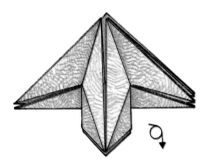

3. Turn the figure over.

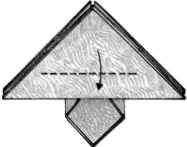

4. Fold the top layer downward at the dotted lines . . .

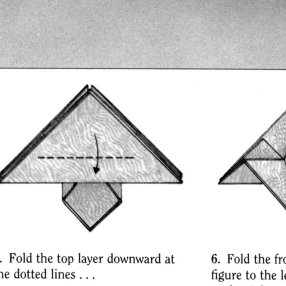

5. . . . as indicated.

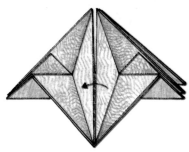

6. Fold the front right part of the figure to the left, the back left part to the right.

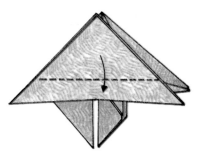

7. Bend the front part downward and . . .

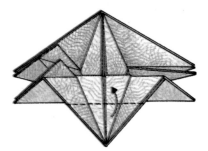

8. . . . fold it upward again.

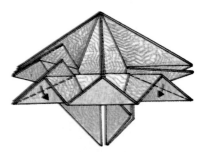

9. Fold the left and right corners down.

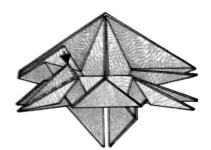

10. Press the corner on the inside downward at the marking.

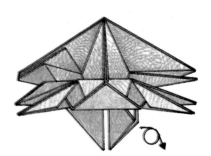

11. Turn the figure over.

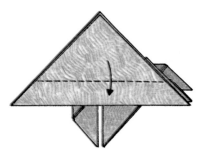

12. Repeat steps 4 to 10 on this side.

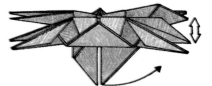

13. Open the right part of the figure and pull the right lower tip upward so that . . .

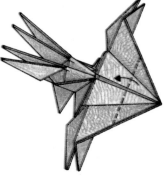

14. . . . a flat triangle is created. Fold only the front corner to the left.

15. Pull out the corner at the marking.

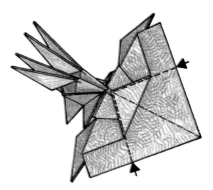

16. Prefold from below at the arrow marking and above at the spine so that the figure stands sturdier.

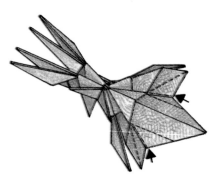

17. Pull the corners forward at the bottom and top.

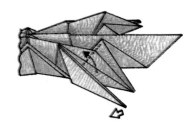

18. Open the front tip and fold upward the other tip.

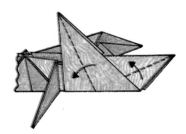

19. Combination fold as indicated.

78

20. Bend the tip downward at the dotted line.

21. Valley fold.

22. Bend the tip upward at the dotted line.

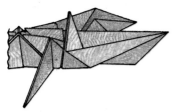

23. Repeat steps 18 to 22 on the back side.

24. Press the tip inward with a combination fold so that a flat surface is created.

25. Zigzag fold for the head.

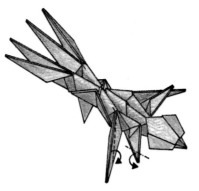

26. Fold to form the four legs on both sides.

27. Open the bottom of the figure. Bend the lower tip upward so that a flat surface is created.

28. Fold the four legs.

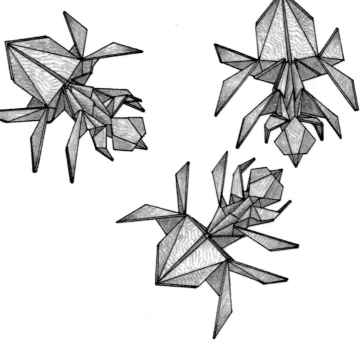

29. Completed ant.

Index

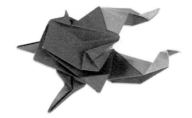